IMAGES
of America

JEWISH
SAN FRANCISCO

IMAGES
of America

JEWISH
SAN FRANCISCO

Edward Zerin
Foreword by Dr. Marc Dollinger

ARCADIA
PUBLISHING

Published by Arcadia Publishing
Charleston SC, Chicago IL, Portsmouth NH, San Francisco CA

Printed in the United States of America

Library of Congress Catalog Card Number: 2006929353

For all general information contact Arcadia Publishing at:
Telephone 843-853-2070
Fax 843-853-0044
E-mail sales@arcadiapublishing.com
For customer service and orders:
Toll-Free 1-888-313-2665

Visit us on the Internet at www.arcadiapublishing.com

*To my wife, Jill, who took me out of my sorrow and
brought me to a new life*

CONTENTS

ACKNOWLEDGMENTS

I stand upon the shoulders and owe grateful appreciation to a myriad of supporters, more than my allotted space allows me to mention. To the Western States Jewish History Association, the Taube Institute for Jewish Life and Culture, and the Jewish Community Federation of San Francisco for their grants that permitted me to tap libraries and museums near and far. To Seymour Fromer, retired executive director and longtime friend; to Aaron T. Kornblum, archivist; and to James Leventhal, director of development, who opened to me the richness of the Western Jewish History Center of the Judah L. Magnes Museum (WJHC/JLMM). To my academic advisor, Dr. Marc Dollinger, the Richard and Rhoda Goldman Endowed Chair in Jewish Studies and Social Responsibility at San Francisco State University; and to my readers John Rothmann, Frances Dinkelspiel, Rabbi Stephen S. Pearce of Temple Emanu-El, and Dr. Stanley Tick, retired from the English Department of San Francisco State University, for their insightful observations. To chief executive officer Thomas Dine of the Jewish Community Federation, executive director Phyllis Cook of the Jewish Community Endowment Fund, the numerous professionals within the Federation, and those working in other Jewish organizations, I offer a heartfelt "todah rabbah." To Dr. Jonathan Schwartz, the staff, and the volunteers of the Jewish Community Library of the Bureau of Jewish Education who guided me to resources. To executive director Nathan Levine and communications manager Aaron Rosenthal of the Jewish Community Center, who gave generously of their advice and time. To Paula Freedman, archivist of Temple Emanu-El, and to Hallie Baron, director of marketing and communications of the Jewish Community Federation, who with especial graciousness made available to me their picture files. To pioneer historian Dr. Fred Rosenbaum for our conversations, which led to my undertaking this project. To my editor, John Poultney, and the staff at Arcadia Publishing, who were ever present offering guidance and lending a needed hand. To my next-door neighbor, youthful and knowledgeable Stacy Passman, whose mastery of the computer and understanding of what, for me, is the new world of electronic publishing made possible the finished manuscript. To the many who dug into drawers and closets for their personal family photographs. And on and on goes my list of supporters, who, though unnamed, have my eternal gratitude.

FOREWORD

When Rabbi Ed Zerin moved to San Francisco after an impressive career in Southern California, he entered a city with a Jewish history quite different from Los Angeles. While Hollywood welcomed the Jewish movie moguls in the first third of the 20th century, most Jews did not arrive until the post-World War II period. They tended to live close to one another, creating Jewish neighborhoods first in Boyle Heights and later in Fairfax, Pico-Robertson, and in the San Fernando Valley.

San Francisco, on the other hand, began its Jewish history a century earlier with the massive immigration to California that followed the gold rush of 1849. The rapid population growth, lack of preexisting Anglo power structure, and trade skills enjoyed by Jewish arrivals combined to create unprecedented Jewish social mobility. From the famed clothing manufacturer Levi Strauss, to the scores of business, political, and social leaders that followed, San Francisco Jews counted the "City By the Bay" as one of this nation's most friendly.

Jewish residents tended to resist the temptation to live in cloistered Jewish enclaves, enjoying instead the opportunity to live and socialize among the larger non-Jewish community. They built grand synagogues that testified to both their material success and to the centrality of Judaism, defined along classical Reform lines, in their San Francisco lives. At Congregation Sherith Israel, congregants commissioned a 1904 stained-glass window depicting Moses's deliverance of the Ten Commandments from California's only naturally glaciated valley, Yosemite National Park. For San Francisco Jews, California emerged as the New Zion and San Francisco as the New Jerusalem. In an American Jewish history often defined by trends in New York City, San Francisco offers a powerful counter narrative that forces us all to reconsider our basic assumptions about what it means to be Jewish in America.

This history captured the attention and imagination of Rabbi Zerin, who has devoted 1,000 hours of intensive and detailed work gathering and editing the vivid photographic history you will find on these pages. In addition to his skills as a rabbi, author, and Jewish historian, Zerin has, for the last half century, devoted himself to the art of photography. His many awards reflect a passion for the visual aesthetic that is reflected so beautifully in this volume.

In the course of preparing this volume, Rabbi Zerin interviewed scores of San Francisco Jewish communal leaders, observers, and historians. He has mined a rich history in order to distill the most salient and powerful photographs that tell the story of San Francisco Jewish life. *Jewish San Francisco* is the ideal product of an author-photographer with the unique skill set to bring all the elements together: history, image, and narrative.

Being a San Francisco Jew for only a few short years, Rabbi Zerin has quickly become one of this city's most knowledgeable Jewish historians. His enthusiasm for San Francisco Jewish life is shared by so many, and this volume is a remarkable testament to the city's novel Jewish history.

—Dr. Marc Dollinger,
The Richard and Rhoda Goldman Chair in Jewish Studies and Social Responsibility,
San Francisco State University.

INTRODUCTION

I am a newcomer to San Francisco, but not a newcomer to Jewish life. Shortly after arriving in my new home, I began visiting the Jewish institutions and meeting Jewish professionals. Riding the MUNI transportation system, I mined a Jewish religious and communal history that began with the arrival of the forty-niners and discovered a Jewish consciousness that distinguishes Jewish San Francisco to this day.

Jews and non-Jews alike were pioneers among pioneers; however, two important factors distinguished the Jewish "forty-niners." While other Americans often had the option of going back to their families in the East, the overwhelming majority of Jewish newcomers came directly from Europe, where political conditions made returning very difficult and most problematic.

Second, many brought with them the knowledge and the skills to supply miners and other town residents with clothing, boots, hats, and other essentials. Frequently they were products of chain migrations, with a brother, uncle, cousin, or friend staying on the East Coast or in Europe sending merchandise west. Those who could afford it stayed in San Francisco, while those who could not compete went off to the mining camps and interior towns where there were fewer stores. Few of those ever mined for gold.

"Within the tents of these sturdy newcomers," recalls the foreword to a notable history of Western Jewry (A. W. Voorsanger's *Western Jewry: An Account of the Achievements of the Jews and Judaism in California, including Eulogies and Biographies and the Jews in California* by Martin A. Meyer, Ph.D., 1916, San Francisco, Emanu-El), "there were conceived plans for the establishment of Jewish communal institutions. When the communities grew and attained material success, synagogues and religious schools, benevolent societies and homes for orphans, the sick and the aged, were erected. [And] In their civic virtues and in those qualities that attest the moral strength of a community the Jewish men and women of pioneer days occupied distinguished rank."

What originally had been a Mexican outpost called Yerba Buena, San Francisco became an "instant city" that grew up suddenly during the gold rush. In 1880, San Francisco became the ninth-ranking city in population in the country and the Pacific Rim's uncontested metropolitan hub. With the great majority foreign born or of foreign-language parentage, the city's 233,000 people accounted for well over a quarter of the state's population. Of this number, San Francisco's 16,000 Jews were exceeded in number only by the Jewish inhabitants of New York City. Today San Francisco's Jewish population approaches 70,000, with a total of 230,000 Jews in the Greater Bay Area—the third largest Jewish center in the United States after New York and Los Angeles.

Reaching out to the larger community, the Jews of San Francisco envisioned and responded to the many needs of the city's growing diversification. Turning within, they "put new wine in old bottles" to meet new world challenges to their ancestral traditions. Like the biblical Noah, they secured their San Francisco ark "from within and without."

Jewish San Francisco is a pictorial update of what started in 1848 and continues into the 21st century. I invite you to mine the past and traverse the present, to explore San Francisco's cultural treasures, and meet a socially responsive Jewish community.

One

Pioneers among Pioneers

The California gold rush was an odyssey into an unknown land for everybody, but the Jewish immigration to California at this time was a unique phenomenon. Jews had migrated to new lands before, but, for the most part, they had settled in metropolitan areas or in smaller towns where there were good prospects of earning a livelihood. They did not know what to expect when they reached California. The claims of travel guides proved to be exaggerated. In 1849, there were no large cities at the mines, only a few small towns; means of transportation from San Francisco to the mountains were poor; and the gold was usually not easily obtained. But the Jews came in large numbers to this unknown land on the strength of the same rumors that motivated the Gentiles. Statistics for the early years are not available, but there are indications that by 1860 there were possibly as many as 962 Jewish males in San Francisco.

—Robert E. Levinson, *The Jews in the California Gold Rush,* page 6

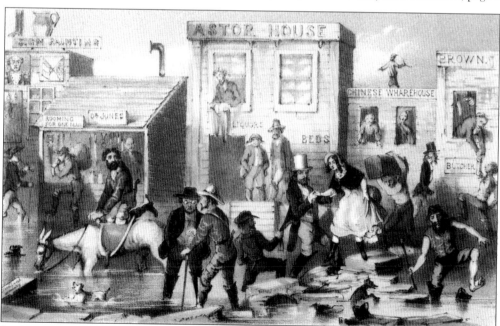

In 1846, Yerba Buena was a quiet Mexican village of approximately 200 people. In 1847, its name was changed to San Francisco, and the following year, the Treaty of Guadalupe Hidalgo ceded California to the United States. By 1849, San Francisco became a sprawling "instant city" of canvas tents and flimsy shacks, quickly ravaged by fires, floods and sandstorms; infested with rats and vermin; and subject to cholera. Gang warfare and murders overflowed onto the muddy streets. (Courtesy Bancroft Library.)

9

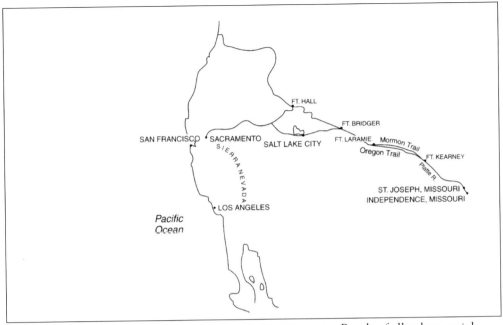

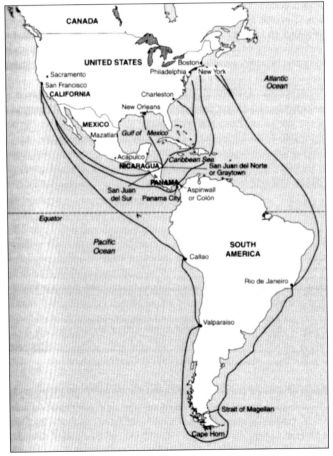

People of all colors, social classes, nationalities, and religions came by every conceivable means—by wagon or on foot across mainland North America, by ship around Cape Horn, or by passage across the Isthmus of Panama or Nicaragua. All too often, when they undertook their journey, they did not realize that the gold fields were over 100 miles inland and that arrival at San Francisco's Golden Gate was just the beginning of another arduous undertaking. The map above shows 1800s overland trails to California from the eastern United States. The lower map indicates gold rush–era sea routes to California from the eastern United States.(Courtesy Wayne State University Press.)

From left to right, Dr. McDonald, Dr. Louis Sloss, and Dr. Swift joined a wagon train to cross mainland North America. When cholera broke out, they left the train as soon as their medical services could be spared, believing that their packhorses could travel much easier and faster than loaded wagons. They arrived safely in California. (Courtesy Bancroft Library.)

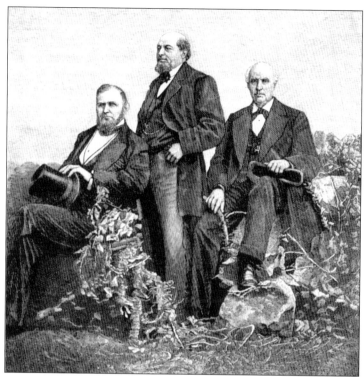

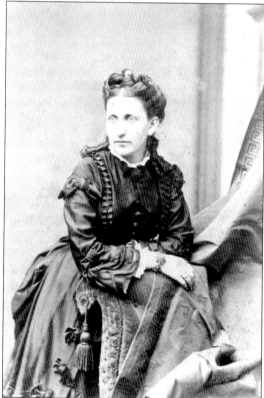

Five-year-old Mary Goldsmith came with her family from Poland via Nicaragua in 1852. She suffered from "chills and fever," and a native had to carry her. Their canoes struggled through streams clogged with dense undergrowth. She married Conrad Prag, a forty-niner and signer of Sherith Israel's constitution, on October 3, 1865. (Courtesy WJHC/JLMM.)

11

Twenty-year-old Adolph Sutro came to California in 1850, taking six days to cross the Isthmus of Panama—four in a boat and a day-and-a-half on a mule. He reported that at night the mosquitoes were as big as grasshoppers and that alligators were all around. (Courtesy Nevada Historical Society.)

At age 24, Bavarian-born Levi Strauss immigrated to San Francisco from New York via the Panama route in 1853 and established a wholesale business. As a representative of his family's New York firm, he imported clothing, underwear, umbrellas, handkerchiefs, and bolts of fabric, which he sold all over California to small stores outfitting miners. The blue jean was born when Jacob Davis, a tailor from Reno, Nevada, informed Levi of a way to make pants stronger by placing metal rivets at the pocket corners and at the base of the button fly. Sharing costs, they were granted a patent on May 20, 1873. (Courtesy Levi Strauss & Co.)

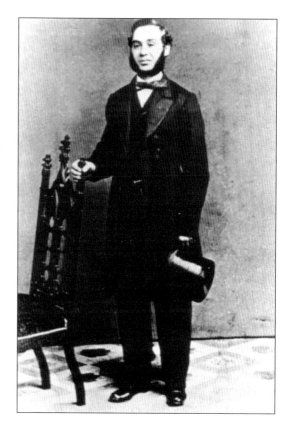

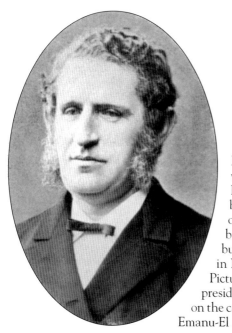

In 1850, Jesse Seligman brought to California $20,000 worth of dry goods, foodstuffs, clothing, and liquor. Fortunately, he moved to the first available brick building at Sansome and California Streets, the only one to withstand the 1851 fire. In 1858, Jesse and his brothers formed the international investment banking business of J&W Seligman Company, headquartered in New York. A San Francisco branch opened in 1867. Pictured is Henry Seligman, who in 1853, at age 25, became president of Temple Emanu-El and exerted more influence on the congregation than any other layman. (Courtesy Temple Emanu-El Archives.)

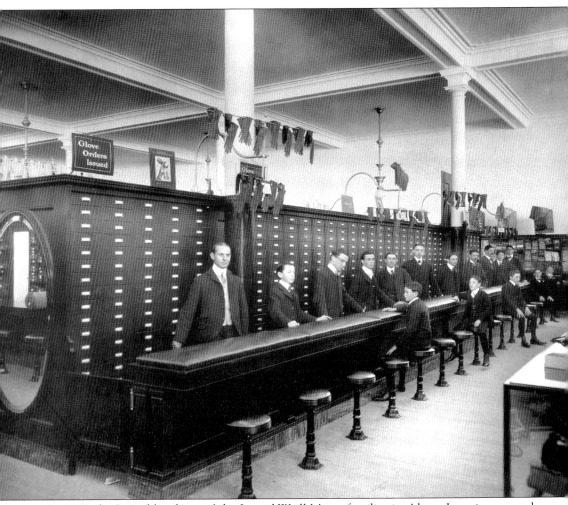

In 1849, the Lazard brothers, of the Lazard-Weill-Meyer families in Alsace-Lorraine, came by steamer via New Orleans to San Francisco, where they sold imported goods from Europe and exported gold bullion. In 1873, they opened the London, Paris, and American Bank, one of the largest on the Pacific Coast. Raphael Weill's White House and its Glove Department later brought opulence and sophisticated buying habits to San Francisco. (Courtesy WJHC/JLMM.)

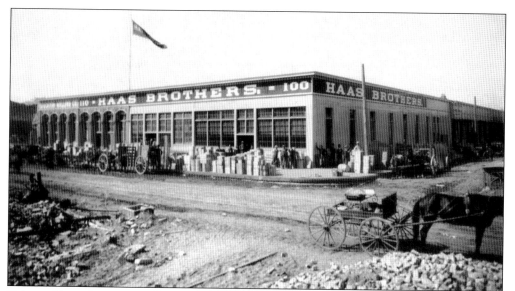

Kalman Haas, from a poor Bavarian family of nine, came to the eastern United States at 19 and worked as a peddler to earn enough money to come to California. In 1851, partnering with Leopold Loupe, he opened a wholesale grocery and fine liquor store at the corner of Davis and California Streets. When Loupe returned to Bavaria in 1865, the business became a family affair, and the name was changed to Haas Brothers. In 1897, the company was incorporated, with cousin William as the first president. The liquor business closed during the Prohibition era. (Courtesy Haas Brothers.)

From a humble beginning...

The story may be true; however, the man in the picture is not Anthony Zellerbach, as so many have written. Anthony Zellerbach and Charles Hagerty were partners in a mining town general store that could not support two families. They flipped coins for ownership. Losing, Anthony moved to San Francisco and in 1869 went into business with Adolph Falk, selling job lots of paper to support his wife, Theresa Mohr, and their nine children. When Falk committed suicide, Anthony took over the business. The above advertisement depicts an employee, not Zellerbach. (Courtesy WJHC/JLMM.)

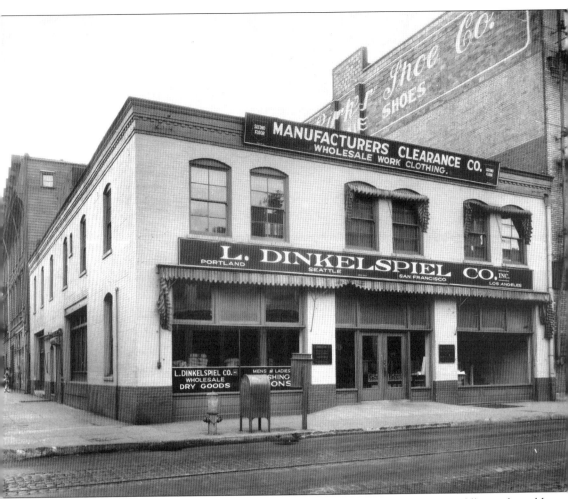

Lazarus Dinkelspiel came from Baden, Germany, around 1850 and worked as a peddler in the gold fields, eventually earning enough money to buy a boat to ferry his goods. When the boat burned, the miners took up a collection to help him start over. By 1853, his business grew into a chain of wholesale dry goods stores up and down the Pacific Coast. His son Samuel took over the business. This photograph shows Lazarus Dinkelspiel's San Francisco store. (Courtesy WJHC/JLMM.)

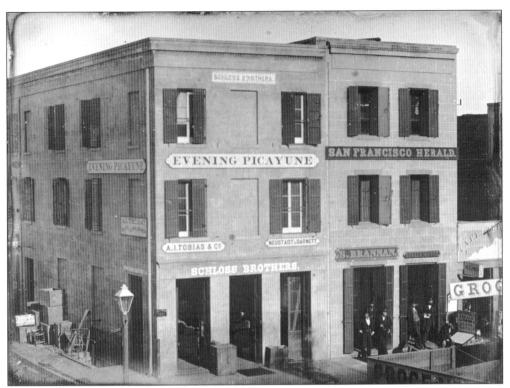

Not every Jew who came to San Francisco persisted or survived. Four close friends of Alexander Mayer lost their lives when his store burned down in 1851. Mayer himself returned east after additional setbacks. Other newcomers wrote of loneliness and financial despair. Goldstein, who had the pox, and Berman, who was insane, also left California. Jewish shops in early 1850s are pictured here. (Courtesy Bancroft Library.)

Abraham Cohen Labatt (Labatto), "Grandee of Sephardic Immigration," partnered in a dry goods store on Kearny Street and chaired meetings to establish a united congregation. When efforts failed, he joined Emanu-El and later served as president. He moved to Galveston, Texas, and died in 1899 at the age of 97. (Courtesy Rosenberg Library, Galveston, *Galveston Daily News*, August 17, 1899.)

Although 30,000 people attended his funeral in 1880, Joshua Abraham Norton was largely an embarrassment to Jews. He arrived in 1849 with $40,000, turned it into $250,000 of real estate, and then lost it all. Renaming himself "Emperor of the United States and Protector of Mexico," he wore a uniform with gold epaulets, used a serpent-headed cane, and printed money. When he died, his estate was worth a $2 gold piece, $3 in silver, and an 1823 franc. (Courtesy California Historical Society.)

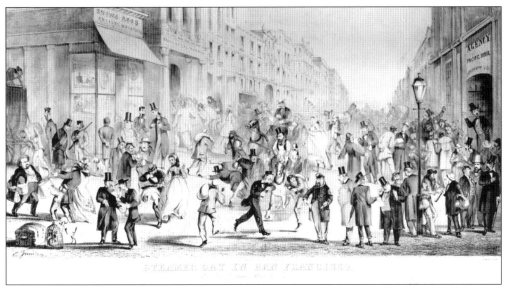

STEAMER DAY IN SAN FRANCISCO.

Because Jews were pioneers among pioneers, there was little overt anti-Semitism. In the first decade, they were welcomed into the social life of the community, winning the respect of their fellow citizens. When a Sunday law was passed in 1858, Solomon Heydenfeldt, a Sephardic Jew and retired state supreme court judge, argued successfully that it was unconstitutional. The Pacific Mail Steamship Company postponed the departure of its steamer for three days to allow Jewish merchants whose businesses had been closed during Yom Kippur to complete their correspondence. Pictured here in 1866 is Steamer Day. (Courtesy Wells Fargo Bank.)

THE JEW PEDLER.

Though rare, there were moments of anti-Semitism. Many newly arrived Europeans, with their foreign appearances and strange customs, especially if they were peddlers, were victims of crimes. Newspapers reported many robberies with anti-Semitic overtones. Peddlers quickly established themselves within permanent communities and engaged in more protected occupations. (Courtesy California History Room, California State Library, Sacramento, California. "The World of California," Hutchins, Christmas 1857.)

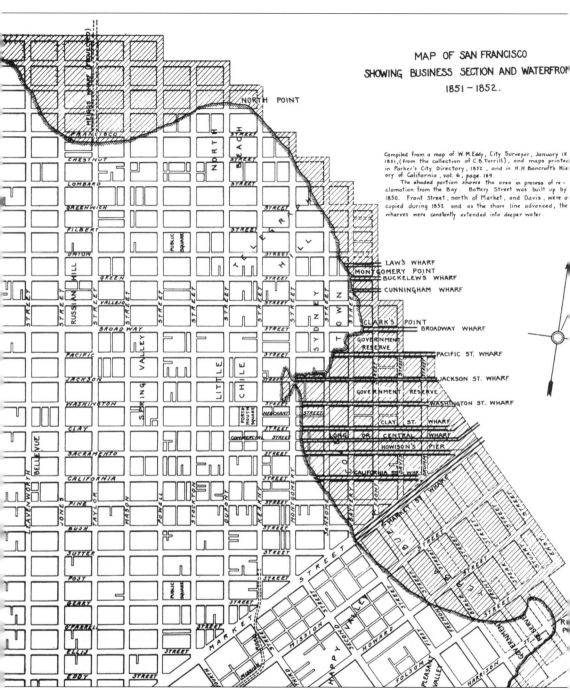

In the early 1850s, San Francisco had a central business district bounded by the bay on the east, Montgomery Street on the west, Market Street on the south, and Pacific Street on the north. Most of the Jews lived beyond Dupont (later renamed Grant) Street. The shaded portion shows the areas reclaimed from the bay. (Courtesy Harvard University Press. *Fortunes and Failures* by Peter R. Decker, page 27.)

Two

A COMMUNITY EMERGES

Through the mud and stink and immorality . . . the unmistakable scent of respectability was in the air. While most of the transient youths gave little thought to the welfare of their community, there were indeed pioneers who cared about the rule of law, and about education, parks, culture, and religion . . . The Jewish merchants were very much a part of that earliest 'establishment.' They sought permanence and security in their uncertain surroundings. Many thousands of miles from their families, they were also clearly longing for the emotional support their faith could provide: fellowship with their own kind, a link to the past and a connection with home.

—Fred Rosenbaum,
Visions of Reform: Congregation Emanu-El and the Jews of San Francisco, 1849–1999, pages 5–6

On Rosh Hashanah 1849, English-born Lewis A. Franklin hosted the first known Jewish service in the Far West in his tent on Jackson Street. During Yom Kippur 1850 in Masonic Hall on Kearney Street, he urged the building of a synagogue and the creation of a strong Jewish community but showed little interest in adapting Judaism to its new environment. (Courtesy Western States Jewish History, personal archives of Norton B. Stern.)

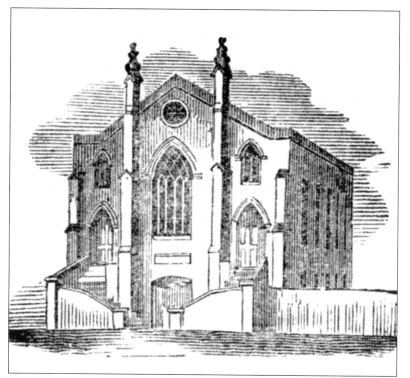

By 1851, two congregations were established. Sixteen men, mostly Bavarian and at least three Sephardim, signed the charter of Emanu-El, meaning "God is with us." (Courtesy Temple Emanu-El Archives.)

Sherith Israel ("the remnant of Israel") consisted of Englishmen, Jews from Posen (annexed by Prussia from Poland), and Russian-occupied Poland. While Emanu-El followed the Minhag Ashkenaz (German ritual) and Sherith Israel the Minhag Polen (Polish ritual), both congregations were Orthodox. (Courtesy San Francisco History Center, San Francisco Public Library.)

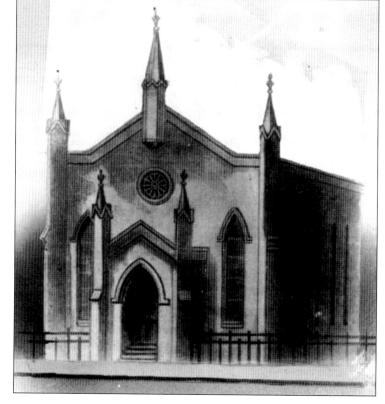

In 1854, the first rabbi at Emanu-El, Julius Eckman, Posen-born with a doctorate from the University of Berlin, laid the cornerstones of Emanu-El on Broadway and of Sherith Israel on Stockton Street. He was an expert on the Hebrew Bible and the New Testament. (Courtesy Temple Emanu-El Archives.)

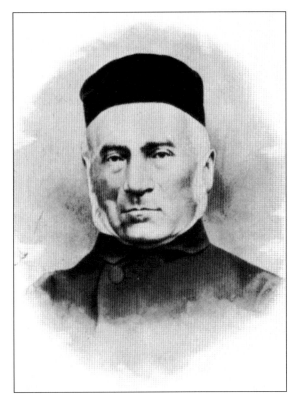

In 1857, Henry A. Henry, an Orthodox rabbi from England, came to Sherith Israel. In the Mortara case, in which an Italian Jewish child was abducted by the Catholic church, he called upon the United States to support European countries in their endeavor to suppress religious intolerance and persecution. (Courtesy Congregation Sherith Israel.)

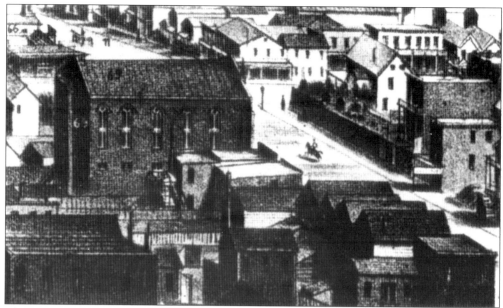

This illustration shows Temple Emanu-El, built in 1854, from above. (Courtesy WJHC/JLMM.)

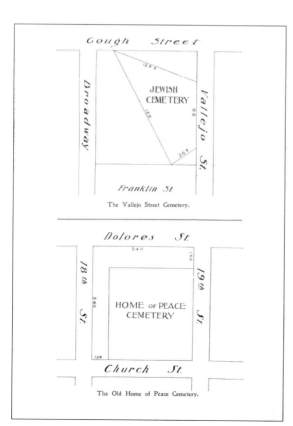

The Vallejo Street Cemetery.

The Old Home of Peace Cemetery.

In 1850, Emanuel Hart presented ground located at Vallejo and Gough Streets to the Jews of San Francisco. This cemetery was used until 1860 when Emanu-El bought ground in the undeveloped Mission District at Dolores and Eighteenth Streets. Sherith Israel bought an adjoining lot at the same time. (Courtesy Temple Emanu-El Archives.)

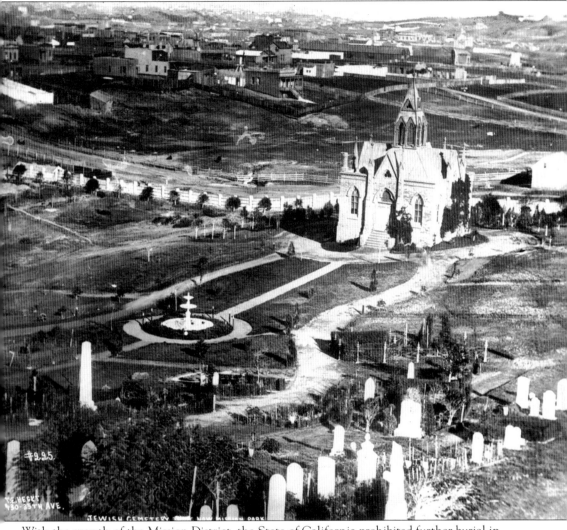

With the growth of the Mission District, the State of California prohibited further burial in the Dolores Cemetery after 1888. New grounds then were purchased in Colma. Emanu-El still calls its section "Home of Peace," and Sherith Israel's section is known as "Hills of Eternity." The old Home of Peace Cemetery is pictured looking west from Church Street. (Courtesy San Francisco History Center, San Francisco Public Library.)

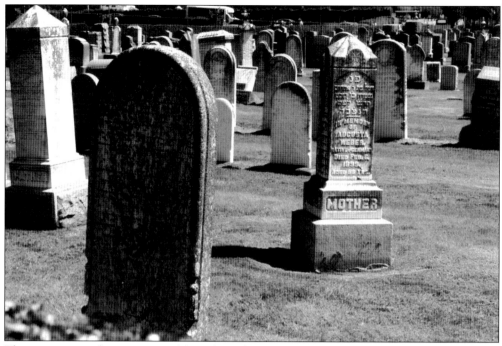

These are memorial graves removed from the Dolores Street Cemetery to Colma. (Courtesy author.)

During the 1850s, Emanu-El began to see itself as an American congregation, shorn of German and Jewish distinctiveness, not strange to non-Jews, with lay rather than rabbinic authority. The Reform Movement was endorsed in 1855. In 1860, Rabbi Elkan Cohn became the first liberal rabbi in the West, introducing Friday night services, seating of men with women, shorter services, and organ music with choir. (Courtesy Temple Emanu-El Archives.)

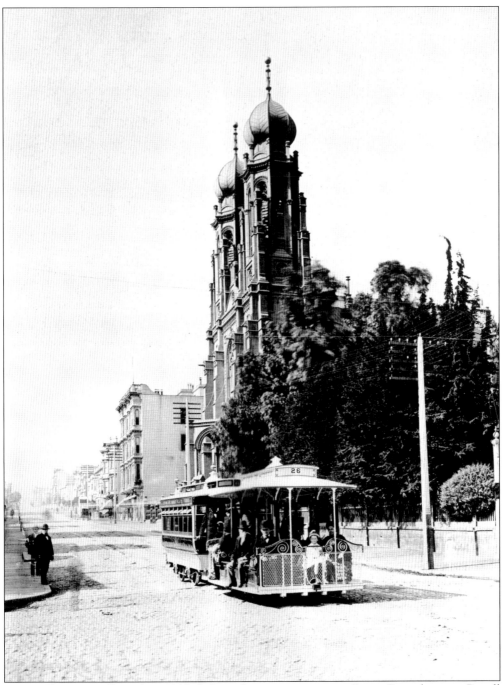

Emanu-El grew rapidly and, in 1866, dedicated a new sanctuary on Sutter Street between Powell and Stockton. (Courtesy San Francisco History Center, San Francisco Public Library.)

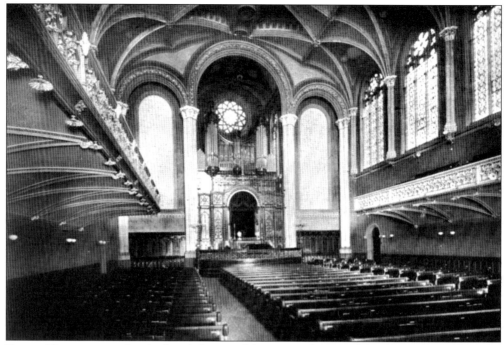

Emanu-El's sanctuary also displayed the temple's outer architectural beauty. (Courtesy Temple Emanu-El Archives.)

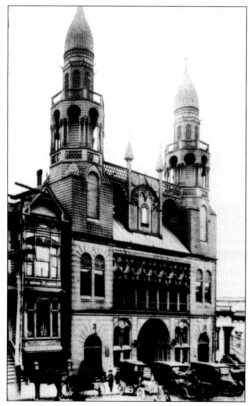

In 1872, Ohabei Shalome split off from Emanu-El and introduced a choir, organ, and family pews but retained the Minhag Ashkenaz ritual. In 1895, a Moorish-style temple at Bush and Laguna Streets was constructed. (Courtesy WJHC/JLMM.)

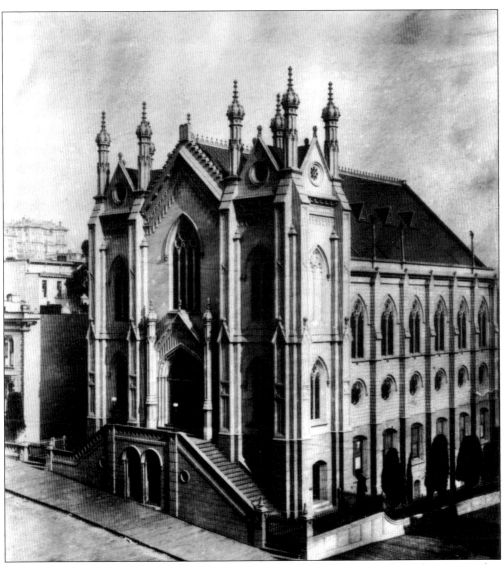

Sherith Israel moved toward the Reform Movement when families were allowed to sit together with the opening of its second building at Post and Taylor in 1870. With the arrival of Rabbi Henry Vidaver in 1874, its membership totaled over 200. (Courtesy WJHC/JLMM.)

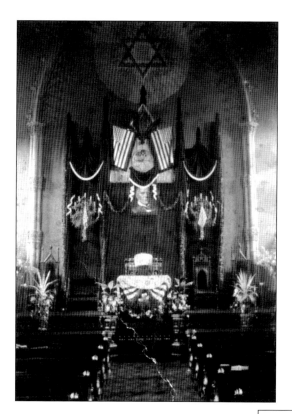

Sherith Israel's beautiful temple interior was decorated with flags in commemoration of the assassination of President McKinley. (Courtesy WJHC/JLMM.)

In the early 1850s, a Sephardic congregation and Polish Orthodox Shomrei Shabbes Synagogue existed temporarily. This advertisement is from *California Hebrew and English Almanac for the Year 5612* (San Francisco: Albion Press, 1851), compiled by Alexander Iser.

By 1861, traditional Beth Israel, with a mixed German and Polish membership, grew under Rabbi A. J. Messing to nearly 200 members. This advertisement was published in the *Gleaner*, October 21, 1864. (Courtesy WJHC/JLMM.)

קהל בית ישראל

The Congregation

BETH YISRAEL

Informs the members of the Hebrew Faith that they have engaged for

Rosh Hoshannah and Yom Kippur,

The Dashaway Hall,

On Posst street, between Kearny and Dupont,

And are enabled to accommonate for the Holidays a large number of Worshippers. With the well known convenience and decorum the public will be satisfied, also with the Readers who are well and favorably known in this community.

For admission apply at the following places :

R. Jacobsohn, 225 Post street·
E. Witkowski, 19 Third street.
S. Goldman, 72 First street.
M. Lyons, Washington street.
A. Livingston, 8 Kearny street,
S. Isaac, 832 Market street.
D. Levitzki, 54 Second street; and on the day before the Holidays at the place of worship.

☞ ספרי תורה ,שופרות ,לולבין

ידים Silver,

And all kinds of Prayer Books for the the coming Holiday o be had of

R. JACOBSOHN,

No 225 Post street, near Stockton.

Nanette (Yettel) Conrad Blochman operated her own millinery business at Fourth Street near Mission. She observed kosher laws and closed the store on Saturdays. Though losing the transient traffic, she helped support the family, employing several milliners. However, her husband, Emanuel, also a trained milliner turned to matzah baking, dairy farming, and wine making. He edited the weekly *Gleaner*, belonged to the Eureka Benevolent Society, was secretary of the Society for the Relief of the Jews of Palestine, and belonged to Ohabei Shalome. In 1864, he started an evening school teaching Torah "as a necessity for Hebrew youth" of both sexes. He also offered religious instruction on Saturday and Bible classes on Sunday. (Courtesy WJHC/JLMM.)

In January 1850, the Hebrew Benevolent Society was organized by Sherith Israel to care for the ill and needy. In September 1850, Emanu-El established the Eureka Benevolent Society "to take more care of Israelites landing here, broken in health or destitute of means." The first president was Philip Runkel, with Simon Lazard as vice president. Women also established mutual aid organizations on their own: the Israelite Ladies Society and the United Benevolent Society of Jewish Women. Pictured is August Helbing, five-time president of Eureka. (Courtesy Jewish Family and Children's Services of San Francisco, the Peninsula, Marin, and Sonoma Counties.)

The Pacific Hebrew Orphan Asylum (subsequently renamed Homewood Terrace and located on Ocean Avenue at Faxon) was founded in 1871 "for the care, relief, protection and improvement of orphan children." The Terrace provided a home for thousands of children before merging with the Jewish Family Service Agency in 1977. Here a group of children pose with a PHOA pet. (Courtesy Jewish Family and Children's Services of San Francisco, the Peninsula, Marin and Sonoma Counties.)

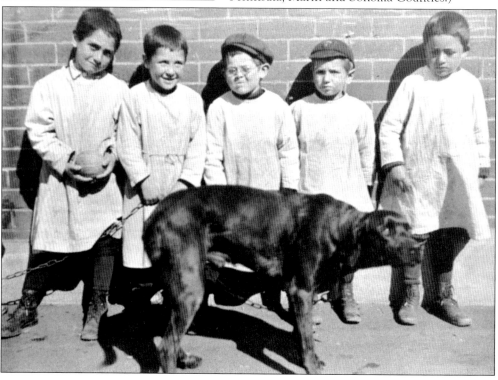

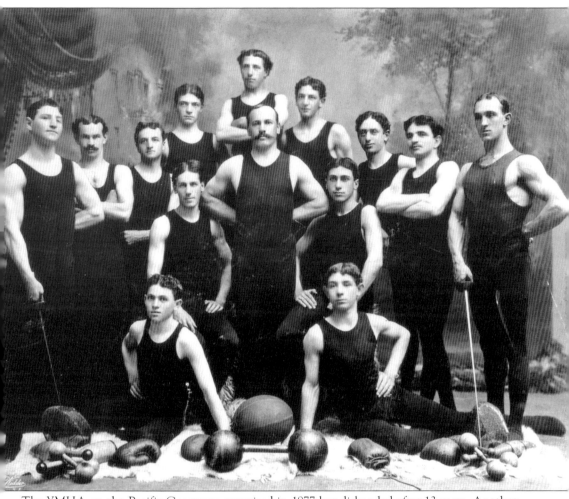

The YMHA on the Pacific Coast was organized in 1877 but disbanded after 13 years. Another effort was made in 1901 "to engender a spirit of Judaism, Fraternity, Sociability, Harmony and Unity among the Jewish young people in this city and state." Despite greatly increased membership, the Y again came to an end in 1913 due to financial problems. The 1902 YMHA Barbell Club is pictured here. (Courtesy WJHC/JLMM.)

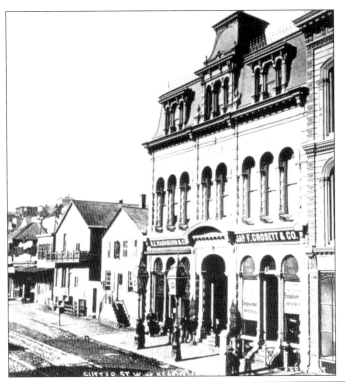

In 1854, a group of professionals, university men, bankers, insurance men, and stockbrokers formed the Verein, the direct ancestor of the present-day Concordia-Argonaut Club. In 1864, the Concordia, swelled by the short-lived Alemanian Club, became the city's first entirely Jewish club. In 1868, the Concordia's second home, Dashaway Hall, was located at 212 Sutter Street. (Courtesy Bancroft Library.)

Toby Edward Rosenthal (1848–1917), son of a Jewish tailor, was symbolic of the upward intellectual and artistic mobility of San Francisco immediately after the gold rush period. In 1875, he became the sensation of the city when his painting *Elaine*, based on Tennyson's poem of King Arthur's Round Table, was stolen while on exhibit at Snow and May's Art Gallery. The city was in shock, and the event was called "the Great Elaine Robbery." Fortunately, *Elaine* was recovered and now resides in the Art Institute of Chicago. (Courtesy Western States Jewish History.)

Three

WEANED ON SOCIAL CONSCIOUSNESS

As communities shot up into towns and cities, the most ambitious and energetic of their Jewish inhabitants rose to prominence, attained leading family status, and passed it on to their offspring. These dynasties had much in common: They were newly affluent . . . pioneers in a mercurial region . . . Americans living through a highly transitional age, and Jews exercising leadership in a largely non-Jewish environment . . . The more successful families had formed their own clique . . . forged of interrelated clans linked by blood, marriage, and business. Before long a code of behavior evolved much like those that governed the newly affluent entrepreneurial circles emerging in other large American and European cities . . . They also made it a rule to belong to the Reform Temple Emanu-El . . . and provided much of that congregation's dynamic leadership . . . They were expected to acquire the tastes and appurtenances of people of rank . . . the young received disciplined training . . . Occupied with fortune and family building, members nevertheless always gave high priority to good works and civic duty.

—Harriet and Fred Rochlin,
Pioneer Jews: A New Life in the Far West, pages 107, 132, 134–137

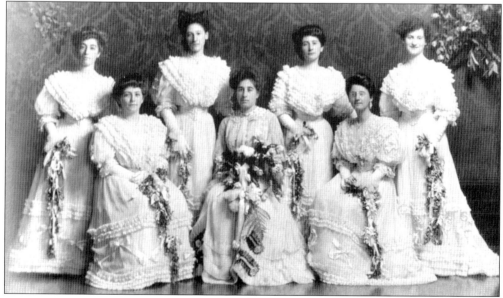

The members of an 1890 soiree, from left to right, are (first row) unidentified, Edith Mack Bransten, and Amy Sussman Steinhart; (second row) Florence Guggenheim Colman, May Lilienthal Levy, Vera Colman Goss, and unidentified. (Courtesy family of Frances Bransten Rothmann.)

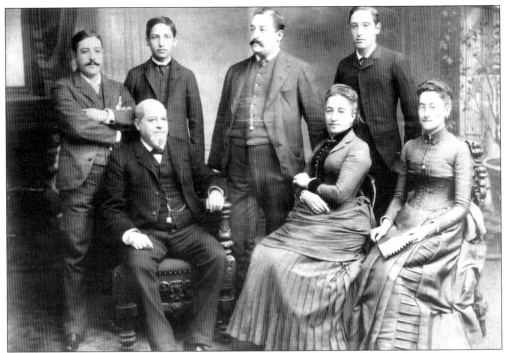

Two Greenbaum sisters and a niece lived on Franklin Street between Jackson and California. Sarah Greenbaum married Louis Sloss in 1855. Their daughter Hannah Isabella (Bella) married Ernest Reuben Lilienthal, son of Rabbi Max Lilienthal of Cincinnati. Louis Jr. remained a bachelor. Sons Leon, Joseph, and Marcus married a Greenwald, an Elsberg, and a Hecht. A three-year-old daughter died. The Sloss family, pictured here from left to right, are (first row) Louis, Sarah G., and Bella; and (second row) Louis Jr., Max C., Leon, and Joseph. (Courtesy WJHC/JLMM.)

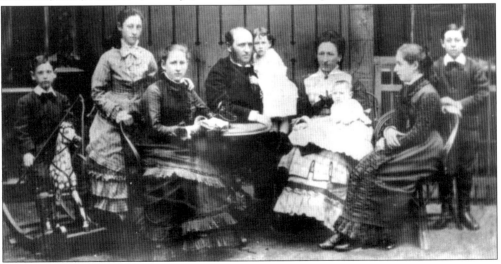

Hannah and Lewis Gerstle were married in 1858. Two daughters, Sophie and Bertha, married two Lilienthal brothers, Theodore and John. Two sons, Marcus and William, married two Hecht sisters, Hilda and Sarah. Clara, Alice, and Florence (Bella) were married to Adolph Mack (whose daughter married John Walton Dinkelspiel), Jacob B. Levison, and Mortimer Fleishhacker. (Courtesy WJHC/JLMM.)

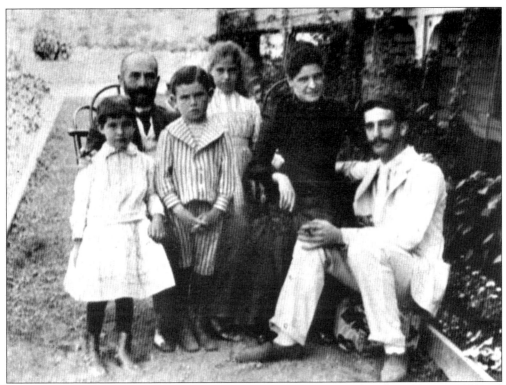

Bertha Greenbaum, the niece of the two Greenbaum sisters, married William Haas in 1880 and had three children. Florine married Edward Bransten, Charles William married Fannie Marie Stern, and Alice married Samuel Lilienthal. Bertha's brother Emil married Caroline (Carrie) Koshland. Pictured, from left to right, are Alice, William Haas, Charles, Florine, Mrs. Haas, and cousin Louis Green. (Courtesy family of Frances Bransten Rothmann.)

The home at 2007 Franklin Street was built for William and Bertha Haas in 1886. After William's death in 1916, Samuel and Alice Lilienthal moved in with her widowed mother. Three blocks away, Alice's sister Florine (Mrs. Edward Bransten) resided at 1735 Franklin Street. Today 2007 Franklin Street is home to the San Francisco Architectural Heritage and House Museum. (Courtesy family of Frances Bransten Rothmann.)

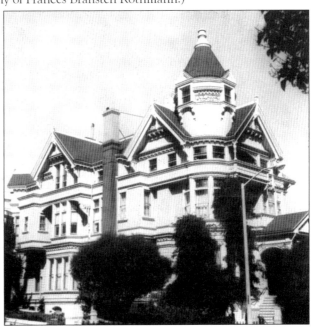

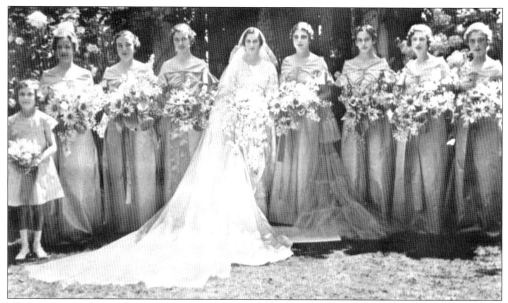

The wedding party in the garden at Atherton includes, from left to right, Ann Lilienthal Haber, Marjorie Gunst Stern, Ann Rosener Pearl, Suzanna Ward, Elizabeth Lilienthal Gerstle, Madeleine Haas Russell, Frances Marie Lilienthal Stein, Margret Samuels Frank, and Frances Bransten Rothmann. (Courtesy WJHC/JLMM.)

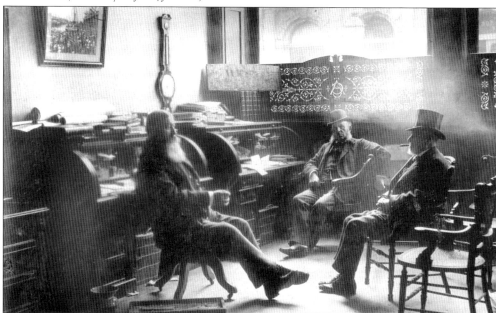

The Alaska Commercial Company at 310 Sansome Street was organized in January 1868 by president Louis Sloss, vice-president Lewis Gerstle, and six others. Based on furs, salmon, and shipping, the business turned Secretary of State William E. Seward's Alaska purchase from Russia, dubbed "Seward's folly," into a stroke of genius. The company protected seals and treated fairly the Aleutian Indian employees for whom they built free housing, schools, hospitals, and churches. Pictured in their office, from left to right, are Gustave Niebaum, Lewis Gerstle, and Louis Sloss. (Courtesy WJHC/JLMM.)

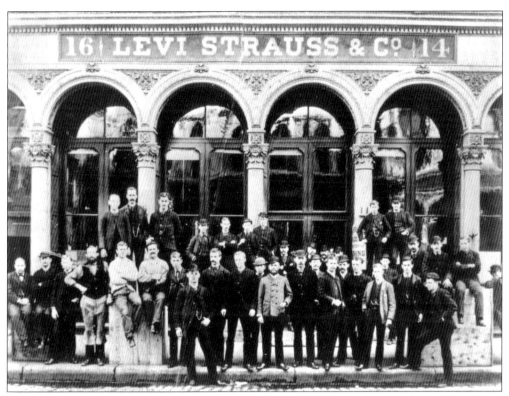

By 1870, Levi Strauss was a very rich man and a generous contributor to worthy Jewish and non-Jewish causes. The Strauss wholesale headquarters is pictured here in the 1880s. (Courtesy Levi Strauss & Co.)

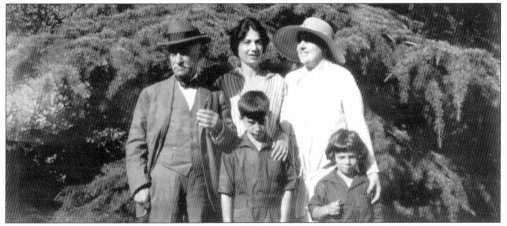

Never married, Levi's estate was divided in 1902 between his sister Fanny Stern's seven children. Four inherited the business—Jacob, Sigmund, Louis, and Abraham. In 1918, "Sig" persuaded his son-in-law Walter Haas, who in turn persuaded his cousin Daniel Koshland, to join the business. Under Haas-Koshland, the company pioneered in minority hiring, employee benefits, and profit sharing, making community involvement and corporate responsibility as conspicuous as the Levi label. Walter died in 1979, followed three days later by Dan. Pictured, from left to right, are Sigmund Stern (grandfather), Elise Stern Haas (mother), Rosalie Meyer Stern (grandmother), Walter A. Haas Jr. (grandson), and Peter E. Haas Sr. (grandson). (Courtesy WJHC/JLMM.)

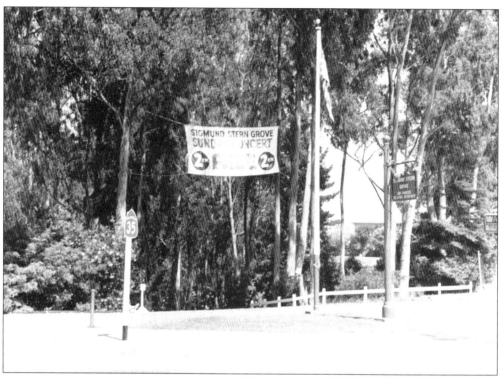

When Sig died in 1928, his widow, Rosalie, gave to the city the 25-acre Trocadero Ranch as the Sigmund Stern Grove. At her own expense, she also had an outdoor theater constructed and established the tradition of free symphony concerts. (Courtesy San Francisco History Center, San Francisco Public Library.)

The Zellerbach fortune grew from pushcart to horse-drawn wagon to the second largest pulp and paper concern in the world. The dynamo was Anthony's son Isadore, who married Jennie Baruh. Isadore and Jennie's son James D. was ambassador to Italy under President Eisenhower. Their other son, Harold, served Presidents Roosevelt, Truman, and Johnson and was involved with the Jewish Community Center and Temple Emanu-El. Harold's son William is chairman of the Zellerbach Family Foundation, the distributor of over $60 million in charitable support. Harold's second son, Stephen, is chairman of the Commission for the Preservation of Pioneer Jewish Cemeteries and Landmarks for the last 43 years. Jennie is pictured here with Isadore. (Courtesy Stephen Zellerbach.)

The Dinkelspiels, Hellmans, Hellers, and Ehrmans constituted a marital alliance of banking (Wells Fargo) and legal profession (Heller and Ehrman). Pictured here, from left to right, are Edward Hellman Heller, Frederick Hellman, the groom Lloyd Dinkelspiel, the bride Florence Hellman, unidentified, and James Schwabacher, who was married to Sophie Dinkelspiel. (Courtesy Frances Dinkelspiel.)

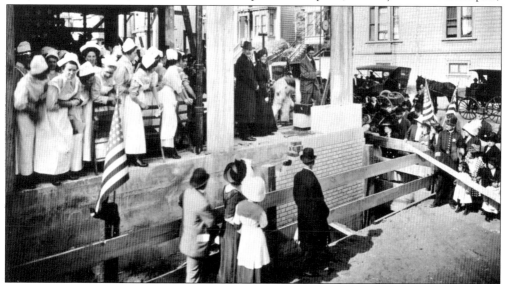

When Esther Hellman died in 1908, her husband, Isaias, donated $100,000 in memory of his wife, who had been president of the Mount Zion Hospital Women's Auxiliary. The picture shows their daughter-in-law Frances Jacobi Hellman laying the cornerstone. Next to her is their son-in-law Emanuel Heller, who was chairman of the building committee. The nurses had starched caps and aprons. This building still stands at the corner of Scott and Post Streets (Courtesy WJHC/JLMM.)

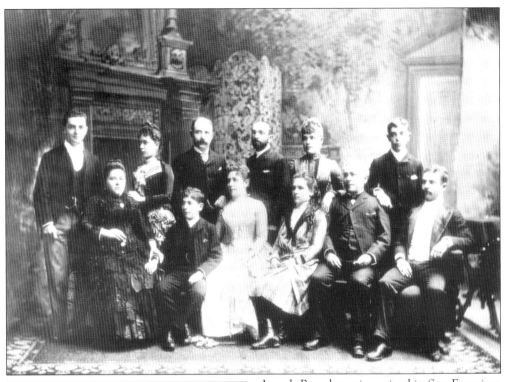

Joseph Brandenstein arrived in San Francisco around 1850 and worked in the gold mines. He then clerked in a general store, where he married the owner's sister Jane and became a partner. In time, the failed gold prospector became a well-to-do tobacco merchant. Joseph and Jane had 11 children. The family, pictured here from left to right, are (first row) Jane, Charles, Flora, Agnes, Joseph, and Manfred; (second left) Jane, Henry, Tillie, Max, Alfred, Eda (Edith), and Edward. (Courtesy Frances Dinkelspiel.)

In 1894, Max Brandenstein and his brothers Mannie and Edward established Max J. Brandenstein and Company, with offices running from Market to California Streets between Drum and Davis Streets. The MJB trademark for tea, coffee, and rice became internationally known. (Courtesy Robert Bransten.)

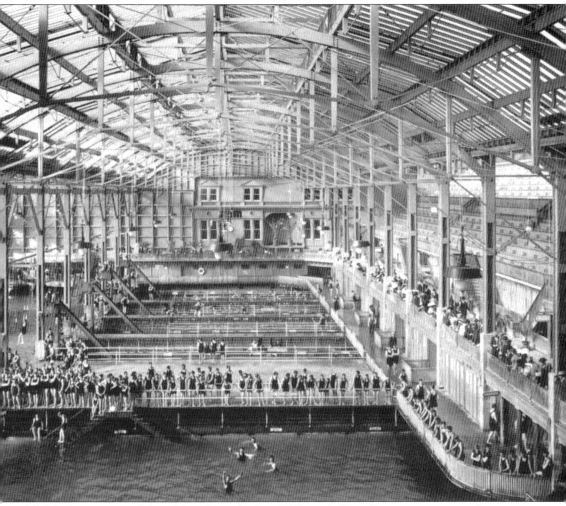

Adolph Sutro returned from Nevada in the late 1870s with $5 million to invest in real estate. In 1885, he opened his private estate on Sutro Heights, with its gardens and panoramic view of the Pacific Ocean, to the public and later gave it to the city. He turned Cliff House and the Sutro Baths into a family resort. His extensive library, including Hebrew manuscripts, was given to the state and housed in San Francisco. In 1894, he was elected mayor on the Populist ticket. Though a freethinker, he married Leah Harris in a religious ceremony in 1885. Rabbi Jacob Nieto of Temple Sherith Israel officiated at his burial. (Courtesy San Francisco History Center, San Francisco Public Library.)

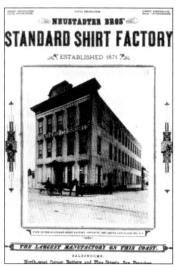

In 1871, the Neustadter brothers established the largest factory on the Pacific Coast at the northwest corner of Battery and Pine Streets. (Courtesy WJHC/JLMM.)

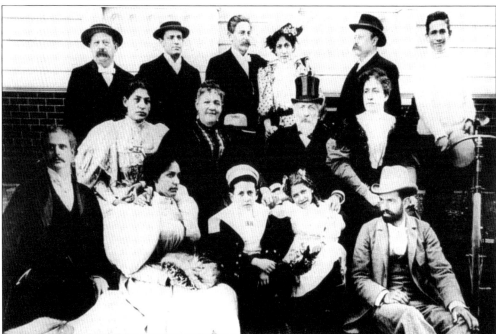

Dubbed "Honest Fleishhacker," Aaron came to San Francisco in 1870 and opened a paper box office, which grew into a major wholesale business. He later was joined by his sons Mortimer and Herbert. Mortimer supported the San Francisco Opera and Symphony, the Museum of Art, and the American Conservatory Theater (ACT). He was president of Temple Emanu-El and on the board of Mount Zion Hospital. Herbert chaired the fine arts and finance committees of the 1939 World's Fair and was known as "father" of the San Francisco Zoo. He donated a children's playground, and the Park Commission named Fleishhacker Pool in his honor. The family, pictured in an 1890 photograph, from left to right, are (first row) Frank Wolf, Blance F. Wolf, Albert Schwabacher, Elsa R. Wiel, and Mortimer Fleishhacker; (second row) Emma Rosenbaum, Delia Fleisshhacker, Aaron Fleishhacker, and Carrie F. Schwabacher; (third row) Sigmund Rosenbaum, Herbert Fleishhaker, Simon Scheeline, Belle F. Scheeline, Sigmund Schwabacher, and James Schwabacher. (Courtesy Delia Fleishhacker Ehrlich.)

William Koshland
Signal, AZ

M. Brandenstein &
Company
San Francisco, CA

The Stone family opened a dairy. The Koshlands (Mrs. Stone's family) became ranchers with their own brand when they accepted cattle rather than money for business dealings. The Brandensteins also had a brand. (Courtesy WJHC/JLMM.)

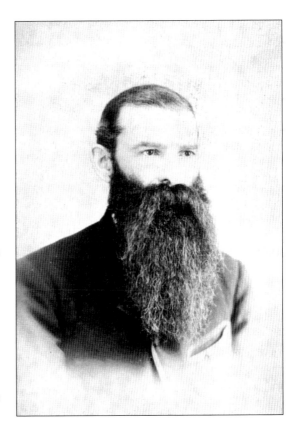

In 1885, Polish-born Sigismund Danielewicz, a Socialist organizer and founder of the Sailor's Union, was a lone voice opposing the exclusion of Chinese from labor unions. Opposed by the political leadership and by many in the Jewish community, he was ousted from his office. His energy was such that he could have been a rich man who owned ships and had schools or union halls named after him, but he chose to stand for the principle of equality. He was last seen in 1910 heading back on foot to the East. (Courtesy Bancroft Library.)

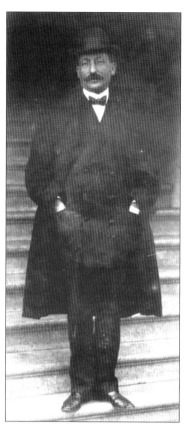

At the beginning of the 20th century, Abe Ruef, son of Alsatian-born Market Street merchant Meyer Ruef, became the "boss" of San Francisco politics. He maneuvered victories for mayors and split fees taken from "clients" for legal services with cooperating public officials. Convicted of graft (illegal or unfair money gain) in 1907, he spent time in San Quentin prison and was then pardoned. Ironically, the trial took place at his Alsatian parent's Temple Sherith Israel, the only substantial building to withstand the earthquake. (Courtesy Bancroft Library.)

While men combined responsibility to their families and business with the duty to support temples and Jewish charitable institutions, women also played major roles in blazing trails, building new towns, in breaking ground for new roles and occupations from which they had been barred, and in philanthropy. When Mary Prag was widowed in 1889, she became one of San Francisco's first Jewish schoolteachers. Upon retirement at age 82, she was appointed as the first Jewish member to the Board of Education. Her daughter Florence married California congressman Julius Kahn and served as his chief advisor during his 12 terms in office. Julius Kahn is pictured with Secretary of State William Jennings Bryan. (Courtesy WJHC/JLMM.)

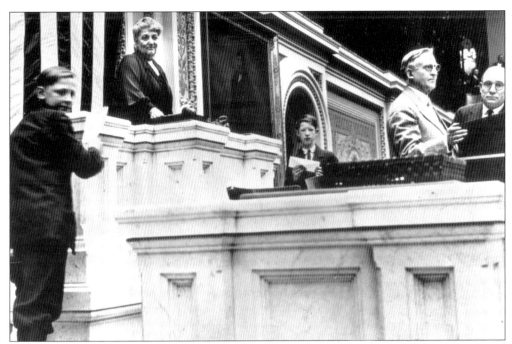

After the death of her husband, Julius, in 1924, Florence Kahn succeeded him for six terms, until defeated in the Roosevelt landslide of 1936. America's first Jewish congresswoman is pictured in 1926 as Acting Speaker of the House of Representatives. (Courtesy WJHC/JLMM.)

Hannah Marks Solomon was orphaned at 13 from Polish immigrant parents and later left with a husband who drank heavily. She is pictured with her family in 1894. From left to right, they are (first row) Selina, a writer and feminist, and Adele Solomon Jaffa, the first woman child psychiatrist; (second row) Theodore, a journalist; Lucius, an attorney and active B'nai Brith member; and Leon, a doctor of philosophy. (Courtesy Aileen Jaffa collection.)

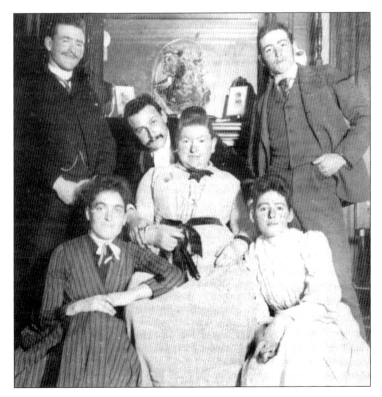

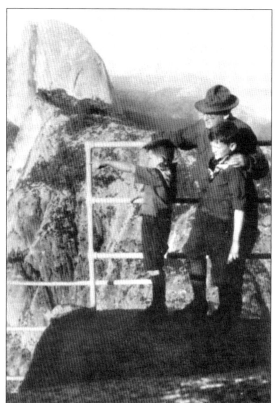

Theodore Solomons, conceiving of a trail that would link Yosemite with the mountains around Mount Whitney, is credited with the idea of the Muir Trail. In 1894–1895, while in his early twenties, he mapped the unexplored High Sierras and named 150 places, of which 28 are still identified. He is pictured with his sons, Leon and David, at Glacier Point. (Courtesy Eleanor Solomons Volcari collection.)

In 1867, not yet 16, a curious and questioning mind brought Harriet Lane Levy to the University of California. Upon graduation, she joined the literary world of Frank Norris and Jack London and later wrote *920 O'Farrell Street*. Moving to Paris, she entered the circle of Gertrude Stein, Pablo Picasso, Georges Braque, and Henri Matisse. When Alice B. Toklas chose to partner with Gertrude Stein, Harriet returned to California. Though pursued by suitors and admirers, she never married. Pictured here are Harriet Lane Levy (left) and Alice B. Toklas. (Courtesy Bancroft Library.)

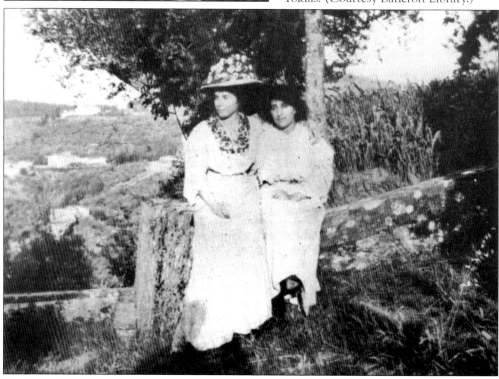

Four

APRIL 18, 1906, 5:12 A.M.

The fires are still raging (April 20) and threaten the destruction of the entire city. The whole business section is in ruins. It includes the city hall . . . all the way down to the ferry, taking in three to four streets on either side of Market . . . including the retail dry goods district, the White House, Lace House, Weinstock, Lubin & Co., Newman & Levinson, Rosenthal, Rueful & Son, in fact, all of Kearny, Grant, Stockton, lower end of Farrell, Geary, Sutter, etc. The wholesale district which takes in Montgomery, lower California, Sacramento, Pine, Bush, Front, Davis and East streets are completely ruined. The whole of Chinatown is a total and perfect wreck . . . All of Knob Hill . . . The fire is now within two or three blocks from Van Ness Avenue . . . Everything that has wheels under it is in use to help carry some of the things people have to have to make out for the night. The oldest, wisest and richest men are at a loss how to meet the calamity that befell the city.

—Mark M. Cohn's account of the San Jose and San Francisco earthquake-fire of 1906 in
William. K. Kramer's *California Earthquakes and Jews*, pages 108–109

A member of Beth Israel for 40 years, Abraham Levitt, who died in 1972 at age 92, remembered the 1906 fire. "I entered the south of Market Street district at Eighth Street. I saw that it was a useless task to try to save that portion of the city. Every friend I had lived in that section and I lost no time in going to their rescue. Our brethren were fleeing with packs hastily put together . . . The Russ Street Synagogue, that noble edifice containing our Holy Torah, was on fire and no one was striving to enter it." (Courtesy Western States Jewish History, private collection of William F. Kramer.)

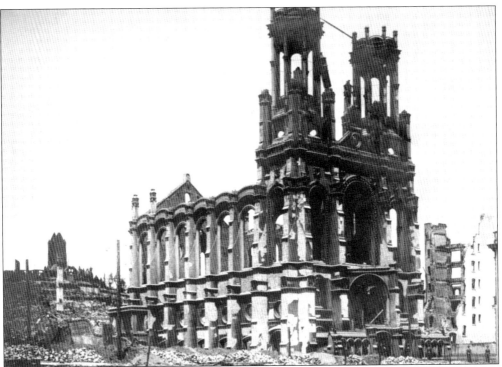

Temple Emanu-El was gutted, with only the towers of the domes and its stone walls remaining. The libraries of Rabbi Cohn and Cantor Edward Stark, the Torah scroll sent by Moses Montefiore to the pioneers in 1851, the minute books, and most of the temple records were in ashes. Services were conducted by Rabbi Jacob Voorsanger in the Calvary Church and for the holidays in the Unitarian church. (Courtesy Temple Emanu-El Archives.)

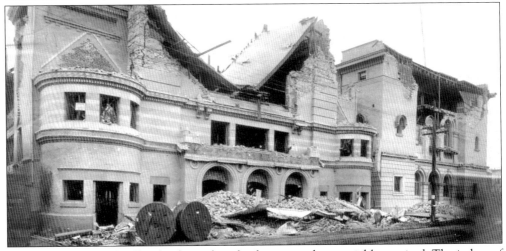

Temple Sherith Israel suffered only earthquake damage and was quickly repaired. The judges of the Supreme bench held court in the temple's vestry rooms, with the income ample to tide over the financial deficits. Rabbi Jacob Nieto held regular services every week. However, Congregation Beth Israel, under construction at the time, was totally destroyed. The 47-second tremor, which caused $68,000 damage, so devastated the conservative-leaning middle class membership that Rabbi M. S. Levy had to go East for assistance. (Courtesy WJHC/JLMM.)

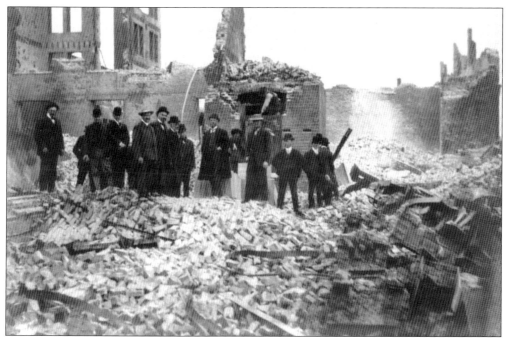

William Haas supervised the opening of the Haas Brothers' vault after a "cooling off period." Vaults and safes opened too soon would burst from spontaneous combustion. The short man standing to the right of the man with his hand in his pocket is Joseph Triest, father of Jane Burrows and grandfather of Lynn Bunim, Nancy Jones, and Steven Burrows. This photograph was taken by William's son Charles. (Courtesy Haas Brothers.)

In 1900, the Eureka Benevolent Society acquired a plot of land on O'Farrell Street near Taylor, paying the estate of Mina D. Solomon the sum of $10,500, and set about constructing a three-story office building on the site. After the earthquake and fire, only the ruins remained. (Courtesy Jewish Family and Children's Services.)

"One hour after the earthquake we were all at work," wrote Rabbi Jacob Voorsanger in the June 1906 issue of *Out West*. He reported that an emergency service automobile brought in the dead and wounded and that people of all ranks and religions began to render service, while an army of physicians, nurses, clergymen, monks, nuns, and Sisters of Mercy stood ready. (Courtesy Temple Emanu-El Archives.)

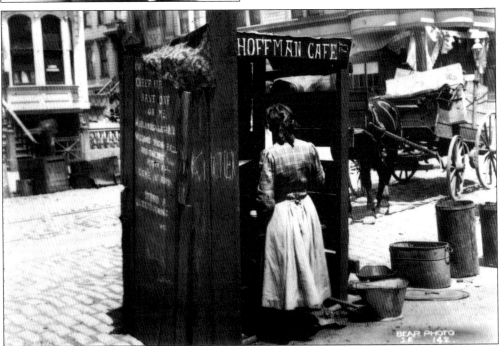

After visiting the relief camps and meeting with the Red Cross, the San Francisco Jewish Relief Committee agreed that by using the reserve funds of local societies and by increasing subscriptions from the wealthier element of the community no immediate appeal was necessary. The Young Men's Hebrew Association was turned over to the authorities for use as a home for the refugees and supply station, and the Hebrew Free Loan Association gave loans without interest to worthy Jews. The people of Oakland opened their synagogues and homes to the refugees. A personal family kitchen was set up and used the sign of the burned out Hoffman Café. (Courtesy California Historical Society.)

RELIGIOUS SERVICES

will be held on

ראש השנה ש״ש ויום כפור ת״רסז

September 20th, 21st 22nd and 29th, 1906

GOLDEN GATE PARK

Camp No. 5 Gentleman $1.00

Majestic Press 1919 Ellis St.

Tickets for High Holy Day services in the Golden Gate Park refugee camp were sold during the aftermath of the earthquake and fire. (Courtesy WJHC/JLMM.)

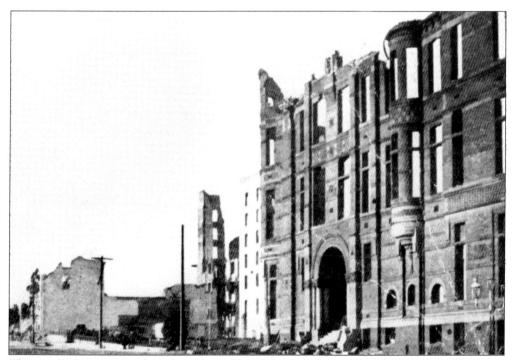

This is all that remained of the Concordia Club after the earthquake and fire. (Courtesy Concordia Club.)

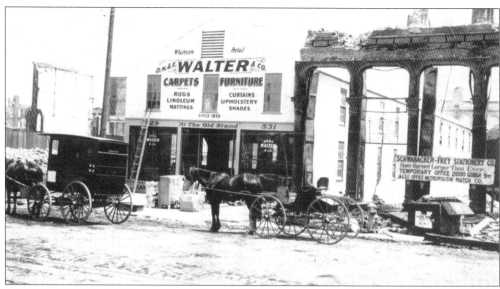

The DN&E Walter & Co. continued business by setting up a tent. (Courtesy of DN&E Walter & Co.)

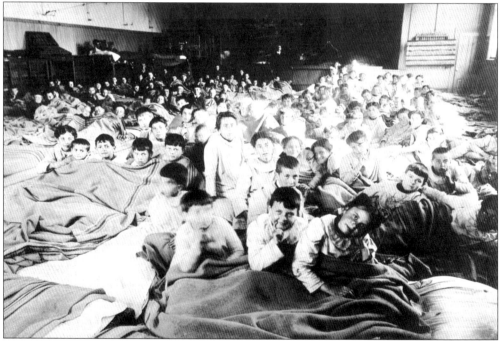

The Home for Aged and Disabled (Orthodox) Hebrews on Lombard Street was totally destroyed, and the 14 residents lived in the open air until aided by the Salvation Army. The Old People's Home on Silver Avenue suffered little loss. The 14,000 volume library in the Eddy Street B'nai Brith building and the records of the Eureka Benevolent Society on O'Farrell Street were lost. Though the building was severely damaged, not one of the 190 Orphan Asylum children suffered. Superintendent Henry Mauser reported: "For two nights we all camped out on the grass. The third day, being terribly moist and foggy, we occupied our Gymnasium." (Courtesy Jewish Family and Children's Services.)

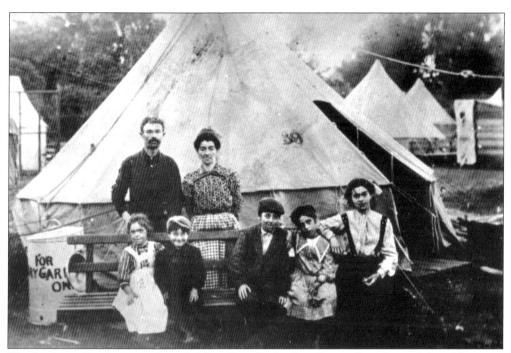

The Lechner family camped in Golden Gate Park after the earthquake and fire. (Courtesy WJHC/JLMM.)

A symbol of the city's revival was the restored Sutter Street Temple Emanu-El. At a cost of $100,000, the new building opened on September 1, 1907. Squat towers replaced the original Russian domes, acoustics were improved, six-pointed chandeliers were hung from an Oregon pine ceiling, a new Kimball organ was installed, a pulpit was hand carved in weathered oak, ark curtains were opened automatically, and opalescent glass windows permitted sunshine to enter the sanctuary. (Courtesy San Francisco History Center, San Francisco Public Library.)

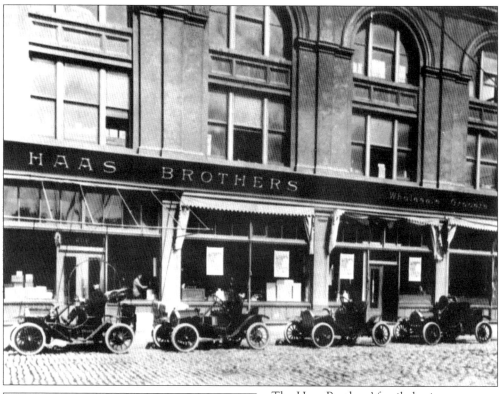

The Haas Brothers' family business occupied new premises and displayed their new automobile inventory in front of the building. (Courtesy family of Frances Bransten Rothmann.)

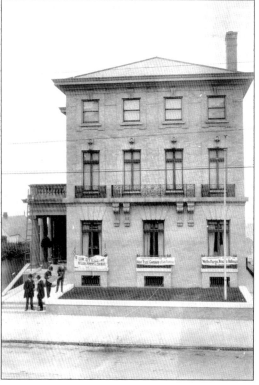

After the earthquake destroyed the Wells Fargo Nevada Bank building on Pine and Montgomery Streets, Wells Fargo, Union Trust, and the Hellers and Powers law firm opened temporary headquarters at 2020 Jackson Street, the home of Emanuel Heller. The banks gave money to depositors despite the fact that there were no customer records available. (Courtesy Frances Dinkelspiel.)

Five

THE NEWER IMMIGRANTS

A few decades after the coming of Jewish settlers of German and Polish origin, East European Jews (following the assassination of Tsar Alexander III in 1883) began to migrate westward. Although they came only in the hundreds in the eighties and nineties, they were to come West in the thousands in the early years of the 20th century . . . facilitated by the Industrial Removal Office . . . established in New York to help disperse immigrants throughout the United States from the heavily congested eastern seaports. In association with the Jewish fraternal order, B'nai Brith, with lodges throughout the country, the IRO between 1900 and 1917 when it went out of existence, transported nearly 80,000 immigrants from the eastern cities . . . Of the 9851 immigrants settled in the 11 Far Western states, only California with 4850 exceeded Colorado with 2791 . . . Most of these immigrants were to settle in the rising cities of the West as a result of the commitment of their fellow Jews to mutual assistance regardless of origins . . . linking Jews East and West in a community of fate, mutual aid and responsibility.

—Moses Richlin, ed.
The Jews of the West: Metropolitan Years, page 9

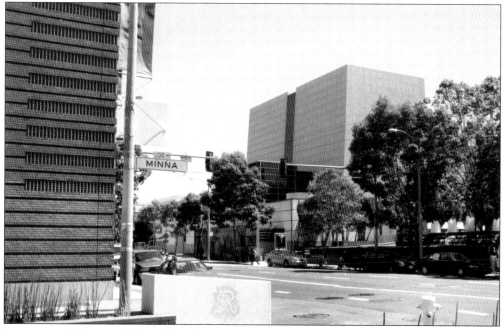

It is estimated that in 1906, no less than 5,000 out of a total Jewish population of 20,000 settled in houses that lined Minna, Natoma, Clementina, and other narrow streets south of Market Street, known as "South of the Slot." This picture was taken on Third Street from the entrance of the St. Regis hotel, next to the San Francisco Museum of Modern Art and across from the Yerba Buena Gardens. (Courtesy author.)

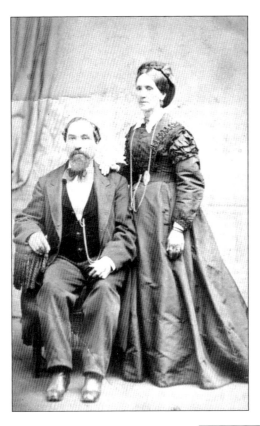

Avram Chaim ben Eliyahu Rubin, born around 1825, and his wife, Chaia bat Alexander Schonwald Rubin, immigrated to the United States from Rzeszow, Galicia (Austria), in 1865 and lived south of Market Street, where he became a small merchant. They were related to the Garren and Wholfeld families in San Francisco. Their two sons, Yechiel (Harris) and Leib (who died young), were born in Rzeszow. This photograph was taken before 1880, the year of Chaia's death. (Courtesy great-granddaughter Marian Rubin.)

Gustav (Gus) and Julie Flamm arrived from New York's East Side in 1891; rented a flat on Harriet Street, south of Market Street; and later moved to the narrow alleys of Minna and Jessie Streets. They also settled his parents, William (Wolf) and Thelma (Tema), in a flat on Natoma Street between Sixth and Seventh Streets. Formerly a tailor in the New York sweatshops, within four years Gus was able to open his own shop at 1435 Polk Street. The sign "G. Flamm—Ladies Tailor" quickly attracted the wealthy clientele between Broadway and California Streets. (Courtesy Jerry Flamm.)

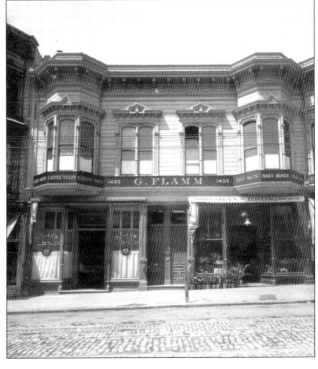

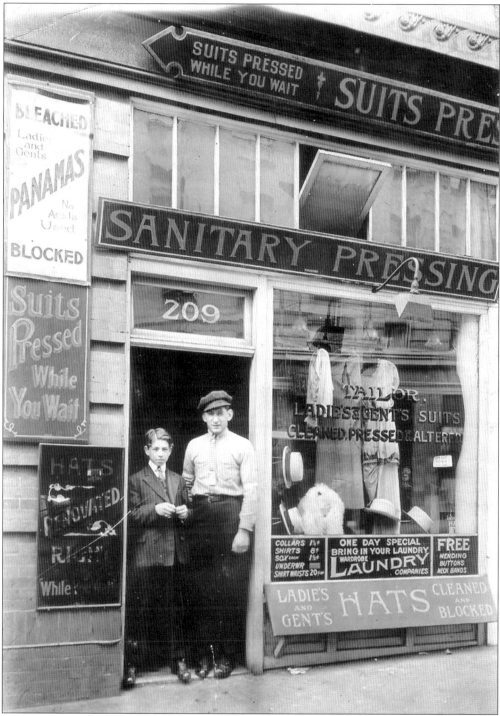

Dave Flamm was 18 months old when his family arrived. As Dave's wedding gift, his father, Gus, financed the cost of a tailoring and pressing business at 209 O'Farrell Street. The shop soon became a hangout for cops. When Gus died in 1920 at age 54, Dave sold his tailor shop and became one of San Francisco's six Jewish policemen. (The boy is unidentified.) (Courtesy Jerry Flamm.)

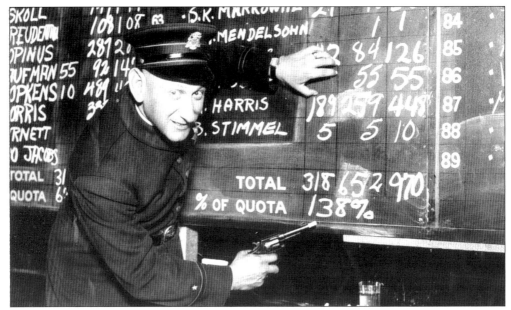

In 1929, the police department suggested that Dave appear in uniform and give the Jewish National Welfare Fund drive a helping hand. (Courtesy Jerry Flamm.)

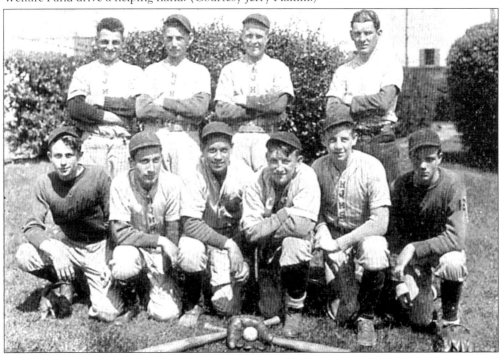

Dave's son Jerry became a journalist, working for the New York *Herald Tribune*, the San Francisco *Call Bulletin*, and the *San Francisco Chronicle*, and worked as press and publications director for the California State Assembly. The author of *Good Life in Hard Times: San Francisco's 20s and 30s* and *Hometown San Francisco*, he loved sports, especially baseball and boxing. Jerry stands second from left in this late 1920s photograph of the Hamilton Junior High baseball team. (Courtesy Jerry Flamm.)

Before 1906, the Fillmore area was largely a white, middle-class district with a significant Jewish population, some immigrants, and a few African Americans. After 1906, the displaced Jews south of Market Street flocked to the Fillmore District and established a flourishing Jewish community. The 1909 Weinstock, Lubin & Co. store on Fillmore Street, between Post and Sutter Streets, is on the right. (Courtesy Jerry Flamm.)

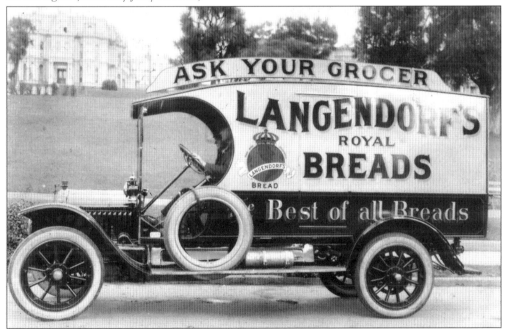

Langendorf's Bakery was considered to be the best Jewish bakery in the neighborhood. Bernard came to Chicago from Vienna when he was 16 and then moved his small bakery to Folsom Street, south of Market, in 1895. After the earthquake, he reopened at 878 McAllister. In 1915, with $400,000 raised from 10 prominent San Francisco people, he built his expanded plant at 1160 McAllister. Emphasizing wholesaling, his fleet of delivery wagons, using two rented horse teams and battery-operated white trucks, covered the city. (Courtesy Jerry Flamm.)

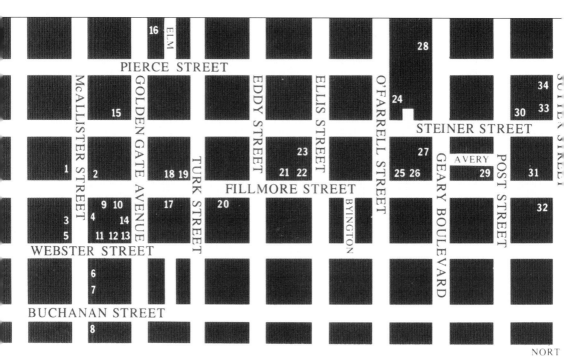

1. *Dave's Barber Shop*, 2. *Cat & Fiddle*, 3. *Royal Ice Cream Company*, 4. *Langendorf's Bakery*, 5. *Ukrain-*
Bakery. 6. *Waxman's Bakery*, 7. *Heineman & Stern*, 8. *Jefferson Market*, 9. *H. Koblick*, 10. *Schubert's Bakery*
11. *Congregation Keneseth Israel*, 12. *White's Kosher Restaurant*, 13. *Schindler's Dining Room*, 14. *Diller'*
Strictly Kosher Restaurant, 15. *Moshe Menuhin, Language Teacher*, 16. *Golden Gate School*, 17. *The Prac-*
tical Hat and Umbrella Works, 18. *Boston Lunch*, 19. *The Carbarn*, 20. *The American Theatre*, 21. *The New*
Fillmore Theatre, 22. *George Haas & Sons*, 23. *Princess Theatre*, 24. *Peacock Confectionary*, 25. *Californi-*
Cafe and Bakery, 26. *The Progress Theatre*, 27. *Congregation Beth Israel*, 28. *Hamilton Junior High School*
29. *The Wagon*, 30. *Dreamland Skating Rink*, 31. *Temple Theatre*, 32. *Goldenrath's Delicatessen*, 33. *Sutte*
Theatre, 34. *Iceland Pavilion*.

The variety of Jewish businesses and activities from McAllister Street and Fillmore Street to
Sutter Street was dazzling. (Courtesy Jerry Flamm.)

In 1925, Yehudi Menuhin used to ride his scooter in the backyard on Steiner Street. Sidney and Florence Ehrman and many other philanthropic Jews supported the Menuhin family so that Yehudi could have the European violin instruction he needed. (Courtesy Jerry Flamm.)

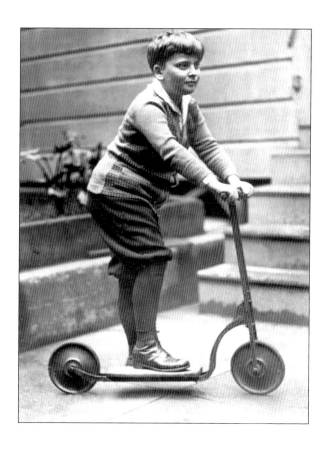

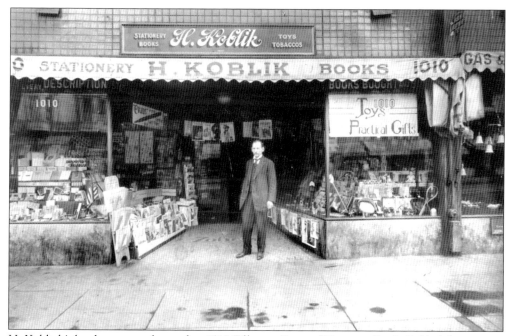

H. Koblick's bookstore was located at 1010 Fillmore Street. (Courtesy Freda Koblick.)

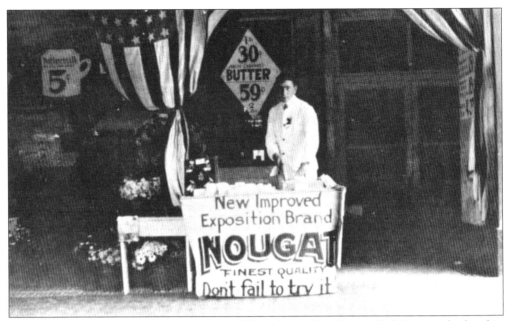

In 1915, Nathan Merenbach, a descendant of Turkish-speaking Jews called Tartars who lived in the Crimea centuries before it was conquered by Russia in the 18th century, sold nougat candy in front of the Washington Market, operated by the Lesser Brothers at the corner of Sixth and Market Streets. A Russian favorite, nougat was made of pure egg whites, honey, and almonds and was cut with a knife when hardened. (Courtesy Ron Merenbach.)

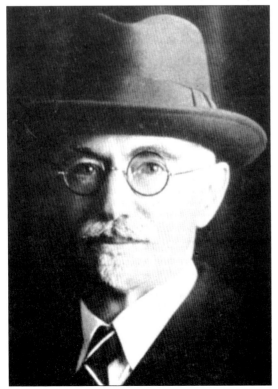

In 1926, Rabbi David Stolper, a native of Lithuania, became superintendent of the Central Hebrew School of the Jewish Educational Society, located at Grove and Buchanan Streets. He guided the program for more than 20 years. Accomplished in Hebrew and Yiddish, he wrote and directed many plays based on Jewish history and lore. He inaugurated the Yeshiva Ktano, a Hebrew High School, to teach advanced courses in Hebrew and Talmud. (Courtesy Lisa and Ze'ev Brinner.)

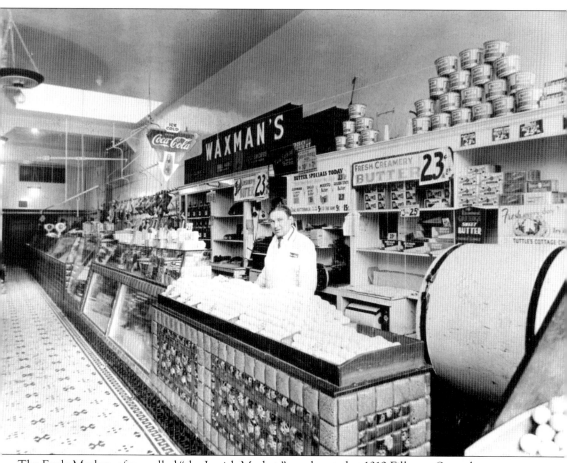

The Eagle Market, often called "the Jewish Market," was located at 1312 Fillmore Street between Eddy and Ellis. The Waxman sign advertised that the Eagle Market carried baked goods from the Waxman Bakery, which also supplied many other grocery stores in the city. George Bloom, the owner, is pictured here in the 1940s. (Courtesty San Francisco History Center, San Francisco Library.)

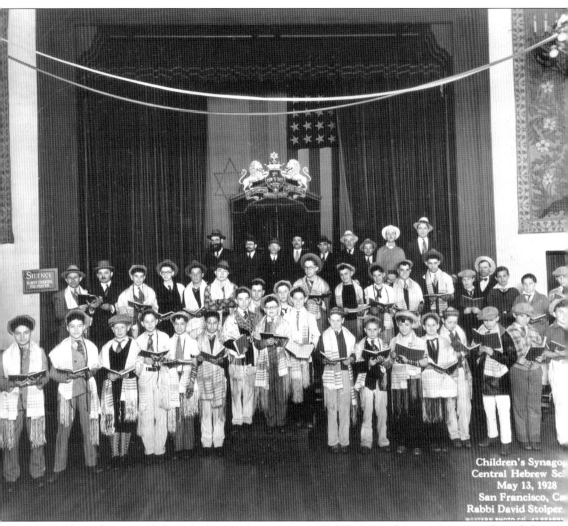

SILENCE
IS MOST ESSENTIAL
FOR PRAYER

Children's Synago
Central Hebrew Sc
May 13, 1928
San Francisco, Ca
Rabbi David Stolper

Rabbi Stolper established the Junior Congregation Kol Yaakov, where students conducted the services, sang the ritual, and read the Torah. In 1992, the reunion committee of Paul Fish, Doris (Fried) Harlem, George Karonsky, Birdie (Golodman) Klein, Irwin Levin, Rabbi David Robbins, Martin Sosnick, and Morris Weinberg announced the planting of two gardens in Israel—one to honor Rabbi David Stolper and the other for their teachers Eva Goldman Beitchman, Joseph Kornfeld, and Graham Unikel. (Courtesy San Francisco History Center, San Francisco Public Library.)

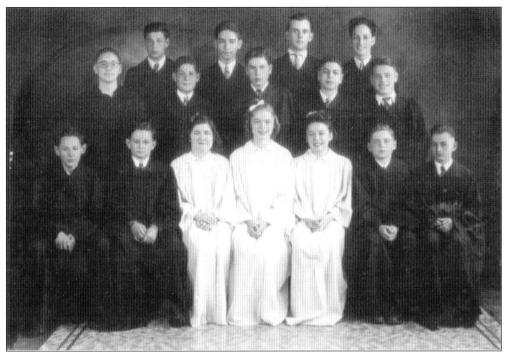

Rabbi Stolper inspired many rabbis, teachers, and community leaders. Where no World War II Jewish chaplain was available, his students who were in attendence would fill in and conduct services. Members of the 1939 class, from left to right, are (first row) Herman Zimmerman, Jack Goldberg, Sulamith Ursditsky, Frances Teitelbaum, Sally Ostroff, (Rabbi) David Teitelbaum, and Daniel Edelson; (second row) Sheldon Lefkowitz, Harry Schlesinger, Louis Ursditsky, and Herman Katz; and (third row) Myron Hersko, (professor) William "Ze'ev" Brinner, Jack Bik, and Selby Morse. (Courtesy Lisa and Ze'ev Brinner.)

Congregation B'nai David, an Orthodox synagogue located at Nineteenth Street between Guerrero and Valencia, was the site of the mikvah (ritual bath). Today the Stars of David still are visible; however, when the Jewish population moved out of the area, the building was sold and converted into an apartment complex. (Courtesy Alan J. Canterbury.)

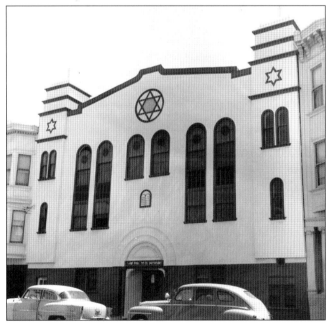

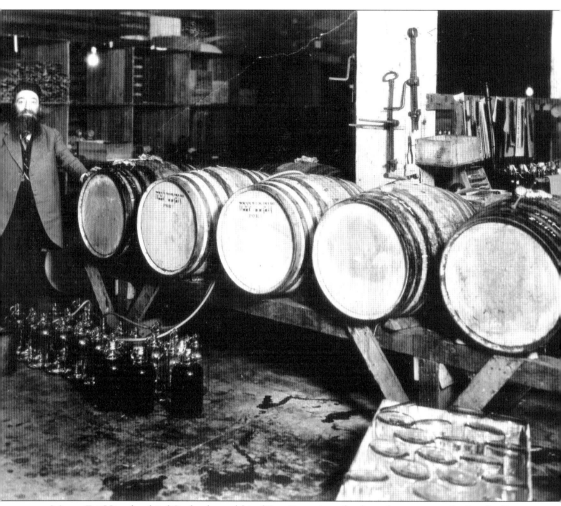

Mayer Zvi Hirsch, chief Orthodox rabbi of San Francisco, kashered sacramental wine for Passover during Prohibition. (Courtesy WJHC/JLMM.)

Six

THE COMMUNITY GROWS

The Jewish Community gives high priority to taking care of Jewish needs here and abroad by combating anti-Semitism, standing with Israel, offering post-Holocaust education, and providing social services. Many organizations also provide assistance to non-Jews by offering job-training, providing medical and food relief in war-torn regions, improving work conditions, making social services available, and helping inner city children learn to read. Whatever and wherever the needs arise, Jewish volunteers are ready to help. This is especially true in San Francisco where many national and international agencies have come to set up shop.

—*Our Jewish Community*, adapted from Dan Pine,
staff writer for J., the Jewish news weekly,
Reprinted in *Resource: A Guide to Jewish Life in the Bay Area*, 2006/5766, page 18

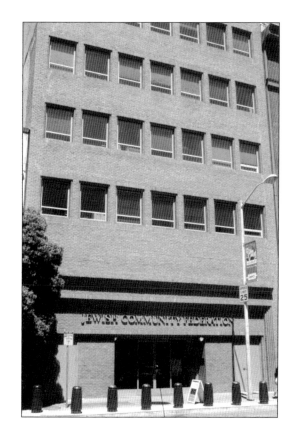

The San Francisco community grows, and the Jewish Community Federation finds a new home at 121 Steuart Street. (Courtesy author.)

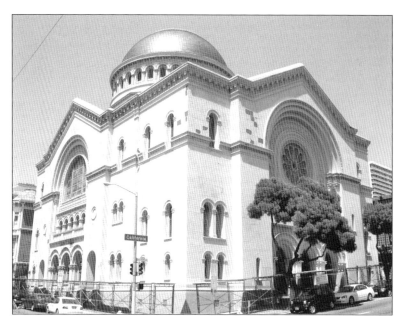

On February 22, 1904, the cornerstone of the new Sherith Israel Temple at the corner of California and Webster Streets was set. It withstood the ravages of the 1906 earthquake. (Courtesy author.)

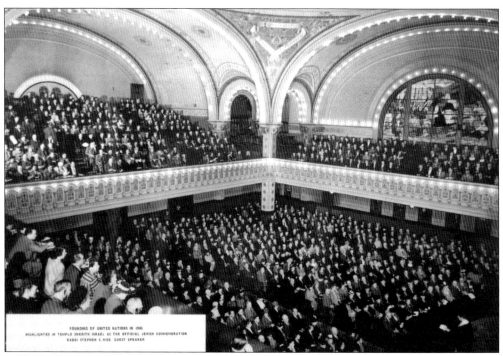

Rabbi Stephen S. Wise was the guest speaker when the Jewish community gathered at Congregation Sherith Israel in 1945 to commemorate the founding of the United Nations. The wood-paneled sanctuary is highlighted by a multicolored stained glass window depicting Moses holding the Ten Commandments, an American flag, and a panoramic view of Yosemite's Half Dome. (Courtesy Congregation Sherith Israel.)

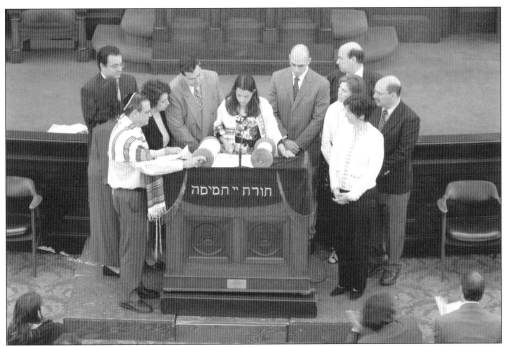

Gabriela Guaiumi, center, is reading from the Torah. With her, from left to right, are Rabbi Lawrence Raphael, Rachel Cauteruccio, Luigi Cauteruccio, Laura Creed, Howard Creed, Jeff Solomon, Tom Bonda, Jody Solomon, Joel Bonda, and Penny Bonda. (Courtesy Congregation Sherith Israel.)

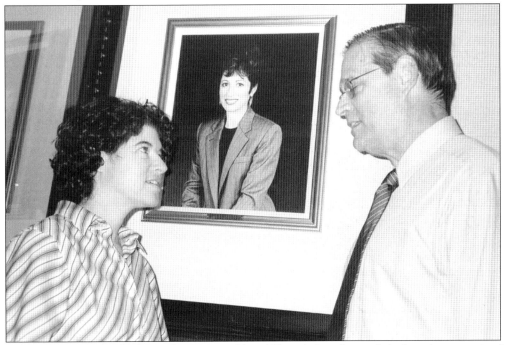

Lawrence W. Raphael, Ph.D., the senior rabbi of Sherith Israel, stands before the portrait of Cantor Rita Glassman as he greets Associate Rabbi Julie Saxe-Taller. (Courtesy author.)

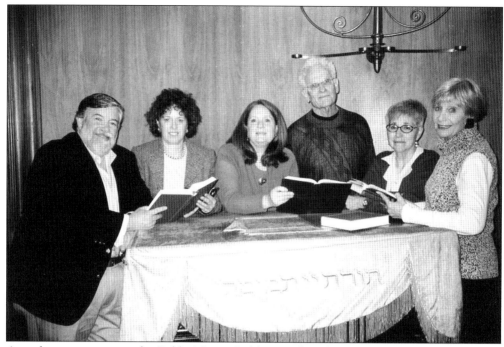

A study group meets in the Rabbi Morris Goldstein Chapel of Congregation Sherith Israel. Pictured here, from left to right, are David Robins, Joanne Godino, Laura Olson, John Dellan, Tobyna Dellar, and Rhoda Wolfe (Courtesy author.)

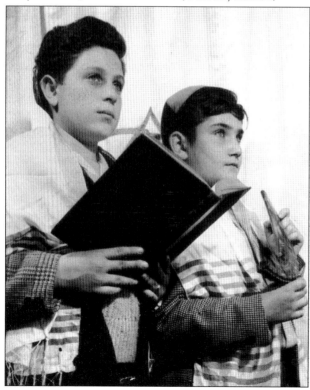

In 1948, Reuven Jaffe, 11, and Stephen Pearlman, 10, prepared for Rosh Hashanah services with the Junior Congregation of the Sunset Hebrew School, maintained by the Jewish Educational Society. (Courtesy Dr. Reuven Jaffe.)

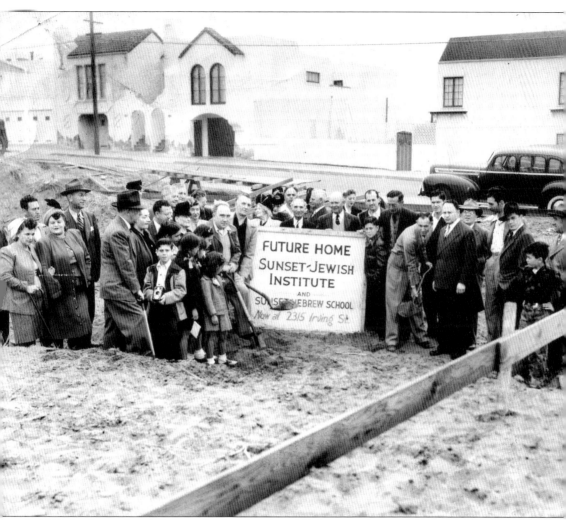

In 1948, the Sunset Jewish Institute broke ground at 1250 Quintara Street. What began as a school of the institute later became Congregation Ner Tamid. (Courtesy Dr. Reuven Jaffe.)

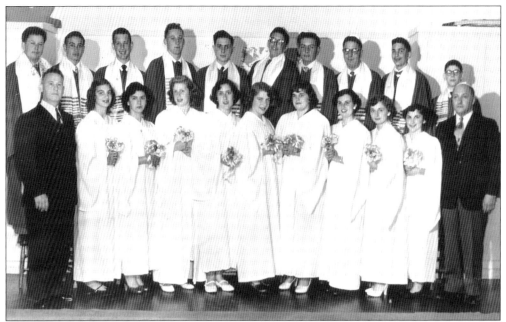

In 1952, Congregation Ner Tamid celebrated its first confirmation class under the leadership of Rabbi William Z. Dalin. Rabbi Dalin's two sons, David and Ralph, were ordained as rabbis. (Courtesy Dr. Reuven Jaffe.)

Students of the Bureau of Jewish Education met with Israeli Foreign Minister Moshe Sharett in 1955. Pictured here, from left to right, are Dr. Alexander Kohanski, Harry Strauch, Reuven Jaffe, Foreign Minister Moshe Sharett, Manny Goldman, and Ernie Abers. (Courtesy Dr. Reuven Jaffe.)

Congregation Ner Tamid's actors performed Yiddish plays for the community. Pictured, from left to right, are (first row) Sammy Dinits, Nadia Altshuler, and Nick Goldberg; (second row) Reuven Jaffe and Gloria Tempkin. (Courtesy Dr. Reuven Jaffe.)

As the community moved west, a new Jewish Community Center of Mediterranean style opened on Monday, November 13, 1933, at Presidio and California Streets. Club programs, swim classes, lecture courses, art exhibits, a theater, an Institute of Jewish Studies, and a wide range of children's programs were organized. Social welfare services were offered for the unemployed and émigrés. The picture shows four members of the center's gymnastics group in 1954. (Courtesy of Western States Jewish History, private collection of Norton B. Stern and William F. Kramer.)

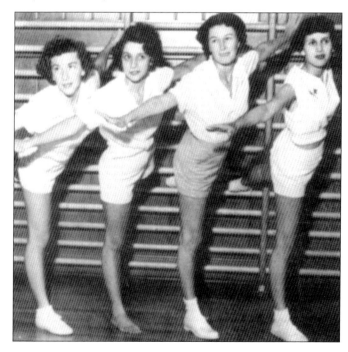

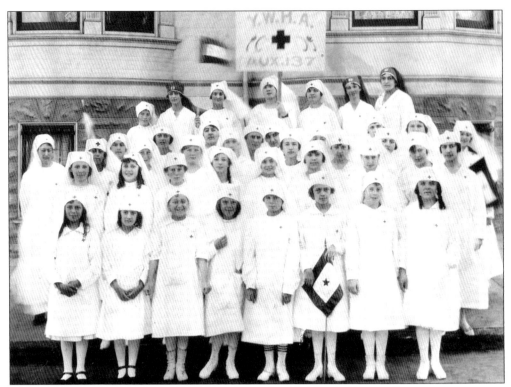

During World War I, when the YMHA was located at 121 Haight Street, all activities were open to military personnel without charge. Rooms were converted into dormitories, and Passover seders were conducted. The YWHA formed a Red Cross Auxiliary. During World War II, the new center on California Street became the headquarters for the local draft board, the Red Cross Relief Center, the Naval Reception Center for overseas evacuees, and an air-raid shelter. Members served as auxiliary firemen, block club leaders, and Red Cross instructors. First aid, civilian defense, and physical fitness classes were scheduled. (Courtesy WJHC/JLMM.)

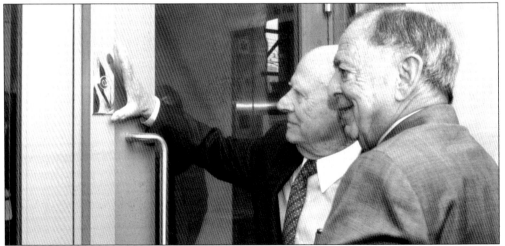

In 2004, Richard Goldman and Gerson Bakar affixed a mezuzah to the newest Jewish Community Center building constructed on the site of the California Street center. (Courtesy Jewish Community Center.)

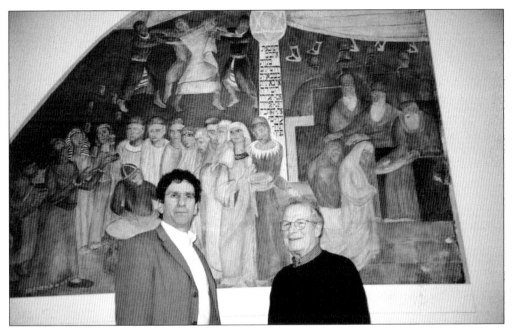

Nathan Levine, director of the new Jewish Community Center building, and director Zev Hymowitz of the old center building stand in the stairway of the third floor of the new building before a restored portion of *The Wedding* mural, preserved from the old building. The mural was painted by Bernard Zakheim, whose murals also decorate the walls of Coit Tower. (Courtesy author.)

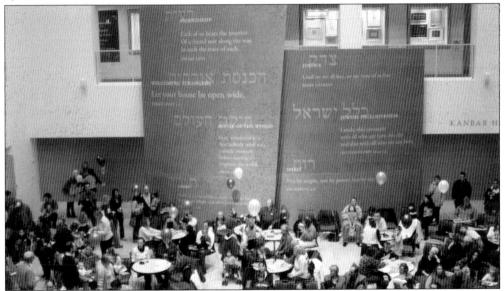

Jewish Community Center members enjoy seven centers of activity: the Koret Center for Health, Fitness, and Sport; the Eugene and Eleanor Friend Center for the Arts; the Taube Center for Jewish Life; the Richard and Rhoda Goldman Center for Adult Living and Learning; the Claude and Louise Rosenberg Early Childhood Education Program; the Gold Center for Youth and Family; and the Kritzer/Ross Emigre Program. In the photograph, crowds gather before the Sheva Midot (the seven measures) in the JCC Pottruck Family Atrium to celebrate Chanukah. The Katz-Snyder Gallery can be seen on the second floor. (Courtesy author.)

The Taube Center for Jewish Life at the JCC organizes lectures, classes, and programs for adults that deepen Jewish literacy. Rabbi Yoel Kahn, director of the program, invited Rabbi David Ellenson, president of the Hebrew Union College Jewish Institute of Religion, as a guest speaker. Dr. Stephen Dobbs, executive director of the Taube Center for Jewish Life and Culture and of the Bernard Osher Foundation; Annette Dobbs, past president of the Jewish Community Federation; and Rita Semel, the executive vice president of the San Francisco Interfaith Council, greet Rabbi David Ellenson. (Courtesy Brian Garrick.)

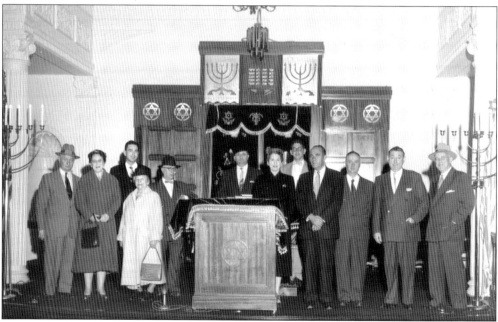

Congregation Beth Sholom is the first major Conservative synagogue in Northern California, tracing its beginnings to 1906, the year of the earthquake. In 1921, a former Baptist church was purchased on Fourth Avenue and took the name Beth Sholom. The cornerstone of the building at 1301 Clement Street was laid in 1934. The next year, Saul White was invited to be the rabbi, and he served until his retirement in 1983. As of 2006, a new synagogue structure is being built on the site of the Clement Street building. (Courtesy Congregation Beth Sholom.)

Rabbi Saul White, ordained in 1935 at the Jewish Institute of Religion (now joined with the Hebrew Union College), was often called the "Dean" of Bay Area rabbis. He was a major force in starting the Bureau of Jewish Education and the Brandeis-Hillel Day School, the first of its kind in the Bay Area. He spoke out strongly on Vietnam, racism, and the West Beirut massacre. Five of his religious school students have studied for the rabbinate, including his son David. (Courtesy Congregation Beth Sholom.)

The Beth Sholom Players, from to right, are (first row) Faye Kahn, director, narrator Ruth White, and Adina Cherin; and (second row) Adrienne Snow, Lila Rich, Marian Saxe, and unidentified. (Courtesy Congregation Beth Sholom.)

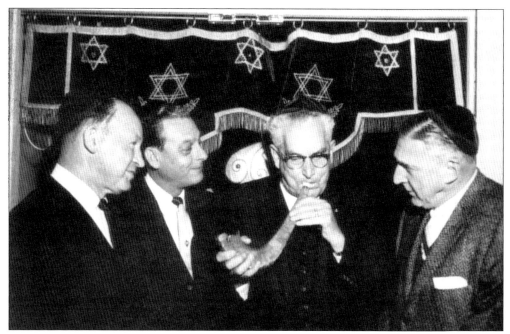

Pictured here, from left to right, are Louis Blumenfeld, Henry Schneider, Sam Schneider (practicing with the shofar), and Abraham Bernstein as they prepare for the High Holy Days at Temple Beth Sholom. (Courtesy Congregation Beth Sholom.)

Known as the Zen Rabbi, Alan Lew, Rabbi Emeritus of Congregation Beth Sholom, is a leader in the Jewish meditation movement that seeks to develop new forms of Jewish spiritual expression. His book *One God Clapping: The Spiritual Path of a Zen Rabbi* interprets two religious traditions in terms of everyday experience. Upon his retirement in 2005, Rabbi Lew (left) is pictured welcoming his successor, Rabbi Kenneth Leitner, who was ordained at the Hebrew Union College in Los Angeles and earned his doctorate from the Jewish Theological Seminary of America in New York. Rabbi Leitner serves as a consulting editor to the Conservative Movement's Committee on Jewish Law. For a hobby, he enjoys restoring antique wooden furniture. (Courtesy Brian E. Geller.)

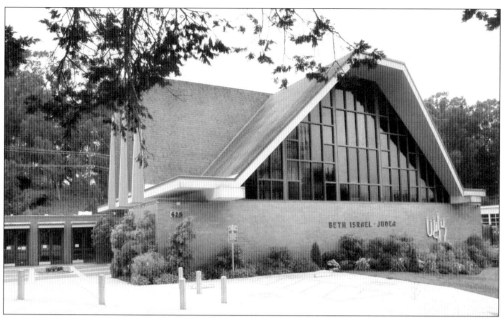

Beth Israel, an original Orthodox Gold Rush-era congregation, once was located at Geary Street near Fillmore Street where the post office now stands. When joined with Temple Judea in 1969 and moved to its present site on Brotherhood Way, Beth Israel-Judea followed a tradtional service on Saturday morning and used the Reform prayer book on Friday evening. Some will remember Cantor Maurice Golden who served in the 1920s, and many are friends of cantor emeritus Henry Greenberg. The rabbi today, Rosalind Singer, is a graduate of the Reconstructionist Rabbinical College and has served both Conservative and Reform congregations. With a background in holistic health, she has helped people living with HIV/AIDS as well as their families and friends. Her greatest athletic feat was biking solo across the United States. (Courtesy author.)

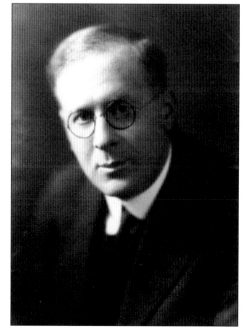

Temple Emanu-El underwent a period of profound reorganization in the 1920s and 1930s. Rabbi Martin Meyer (1910–1923), belonging to the first generation of California-born Reform rabbis, saw himself as a healer and builder of the entire Jewish community, bringing the immigrant and the native born closer and making peace between the Reform and the Orthodox. He advocated Zionism, women's rights, and community service and sought to restore the ceremonies of baby naming and praying for the ill into the temple. (Courtesy Temple Emanu-El Archives.)

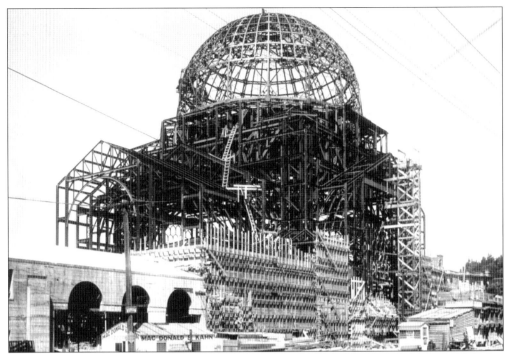

On the weekend of April 16, 1926, exactly 20 years after the earthquake, the new Lake Street Temple, with its adjoining "temple house," was dedicated as a "synagogue center," open to all forms of Jewish expression and accessible to people from all walks of life. (Courtesy Temple Emanu-El Archives.)

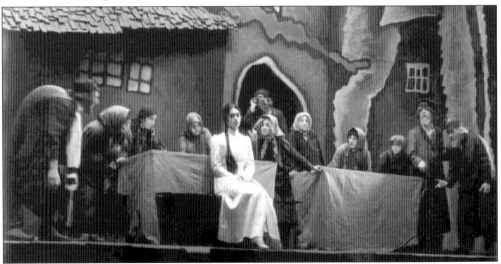

The Temple Players, a drama group involving many young people, was formed. Active members included Edward Bransten; Conrad Kahn, son of Julius and Florence Prag Kahn; and Charles Levison (Lane). It was there that Mortimer Fleishhacker Jr. met his future wife, Janet Choynski, granddaughter of the pioneer journalist Isadore Choynski. In 1928, after two months of rehearsals with a cast of 55, the players produced S. Ansky's famous play, *The Dybbuk*, with Carolyn Anspacher in the role of Leah, the girl possessed by the soul of her dead lover. (Courtesy Temple Emanu-El Archives.)

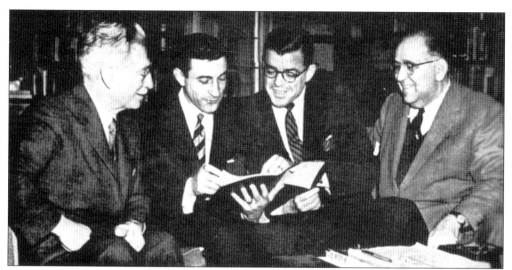

With the 1950 staff of Cantor Reuben Rinder, Rabbi Alvin I. Fine, Assistant Rabbi Meyer Heller, and the amiable Louis Freehof as executive secretary, the temple moved to meet the influx of World War II veterans and the religious education of their children. Hebrew was introduced into the religious school curriculum, and the bar mitzvah program was expanded. For the first time since its Orthodox beginnings, the rabbi wore a modified tallit. With the establishment of the State of Israel, the previous anti-Zionist spirit of the American Council for Judaism was defused. (Courtesy Temple Emanu-El Archives.)

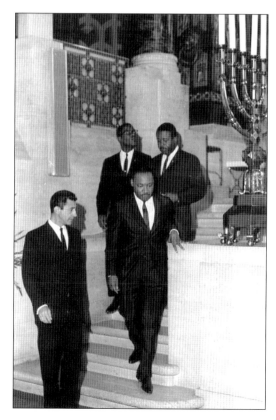

Rabbi Fine (1948–1964) used the influence of his pulpit to counteract intolerance. He attacked the degrading black-face minstrel shows being performed in the high schools. He honored Rev. Martin Luther King Jr. with a temple reception and escorted King, Ralph Abernathy, and an aide through the sanctuary. (Courtesy Michelle Ackerman.)

Rabbi Joseph Asher (1968–1986) was one of the first large-congregation senior rabbis to appoint a woman assistant, Rabbi Michal Bourne. Upon the suggestion of Assistant Rabbi Brian Lurie, he introduced confirmation class trips to Israel and secured scholarships from the Temple Board. He also urged his congregants and rabbinical colleagues toward "sacrificial giving" to the UJA and the Israel bonds drive. (Courtesy Faye Asher.)

Great-grandniece of Levi Strauss and daughter of Walter and Elise Haas, Rhoda Haas Goldman, profoundly affected by her visit to Auschwitz in the late 1970s, became one of the most influential leaders in the Bay Area Jewish community and one of the most prominent philanthropists in North America. As president of Temple Emanu-El (1991–1993), she completed major renovations, restored fiscal solvency, and in a gracious manner and with good judgment helped resolve critical internal problems. (Courtesy Temple Emanu-El Archives.)

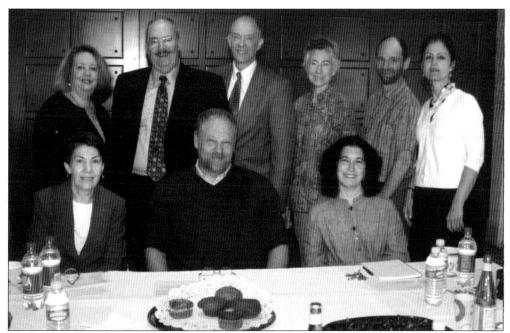

Rabbi Stephen S. Pearce (since 1993) considers the essence of his rabbinate to be "sacred trust" between congregants and rabbi and "matters of the heart" in which members consider their spiritual legacy by writing "ethical wills" for their children. Pluralistic in his approach, an ecumenist in his outreach, and an environmentalist in his concern, he advocates an "open door" policy for the temple. The 2006 management staff, from left to right, are (first row) Terry Kraus, Rabbi Peretz Wolf-Prusan, and Abra Greenspan; (second row) Cantor Roslyn Barak, Gary S. Cohn, Rabbi Stephen S. Pearce, Rabbi Helen T. Cohn, David Worton, and Lani Zinn. Rabbi Sydney B. Mintz is not shown. (Courtesy author.)

Cantor Reuben Rinder (1913–1966) was a fervent Zionist and a strong advocate of introducing traditional Jewish music into Reform liturgy. He commissioned separate works for the Shabbat worship, both called "A Sacred Service." With the financial help of Daniel Koshland, Ernest Bloch composed one complete service, and with the financial help of Clara Heller, Darius Milhaud composed a second complete service. He also found patrons for advanced violin studies for Yehudi Menuhin in Sidney and Florence Ehrmann and Jennie Zellerbach and for Isaac Stern in Hattaie Sloss. His wife, Rose ("Rowie"), organized the first Hadassah chapter in San Francisco. (Photography by Eric Mann; courtesy Temple Emanu-El Archives.)

Cantor Joseph Portnoy (1959–1986), with the help of the Zellerbach Fund, commissioned Israeli composer Sergiu Natra to write the sacred service "Avodat Hakodesh," based on the new Reform prayerbook of 1970. The cantor (standing) is pictured with Ludwig Altman, the temple organist, himself a distinguished composer and international performer. (Photograph by Gary Haas; courtesy Temple Emanu-El Archives.)

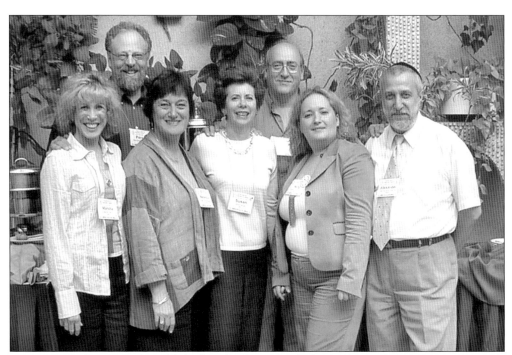

In 2006, Temple Emanu-El established a school-to-school relationship with the progressive Jewish community in Moscow. Pictured here, from left to right, are Marsha Felton of the San Francisco office of the World Union for Progressive Judaism, Rabbi Peretz Wolf-Prusan of Temple Emanu-El, Becki Wolf-Prusan, and (second from right) Cantor Roslyn Barak of Temple Emanu-El. The others are representatives of the Moscow community. (Courtesy Rabbi Peretz Wolf-Prusan.)

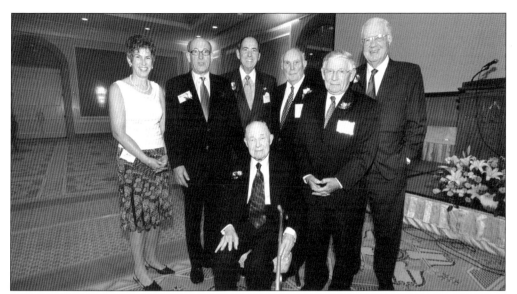

Temple Emanu-El honors its seven living presidents with a festive dinner at the Four Seasons Hotel. An added highlight is the celebration of the 100th birthday of Louis H. Heilbron. Pictured, from left to right, are Ann Blumlein Lazarus (2001–2004), Mortimer Fleishhacker III (1988–1991), Stuart B. Arnoff (1996–1998), Bruce K. Denbeim (1982–1985), and Harold S. Stein Jr. (1998–2001). Seated is Louis H. Heilbron (1954–1957). (Courtesy Susan Adler.)

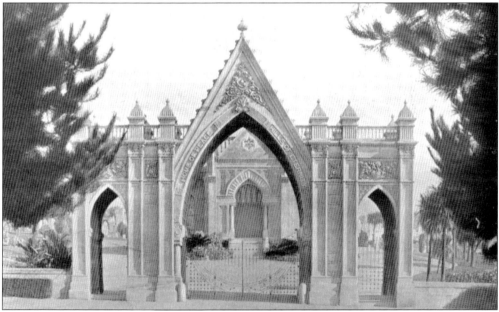

Two Jewish cemeteries were dedicated in 1889 in Colma to replace the earlier cemetery in Dolores Park. Temple Emanu-El's Home of Peace also provides burial sections for Congregation Beth Sholom, Burlingame's Peninsula Temple Sholom, and World War II veterans from the former Soviet Union. Temple Sherith Israel's Hills of Eternity also provides burial sections for Congregations Or Sholom and Shaar Zahav and Peninsula's Congregations Beth Am, Beth Jacob, Kol Emit, and Peninsula Sinai. Pictured is the entrance to the Home of Peace and Hills of Eternity cemeteries. (Courtesy Temple Emanu-El Archives.)

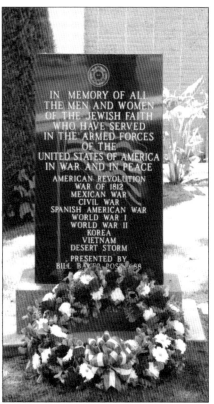

Salem Memorial Park was established in 1877 by Congregation Beth Israel as a designated section of San Francisco's City Cemetery near Ocean Beach. In 1891, Salem Memorial Park became the third Jewish cemetery located in Colma and was purchased from the merged Congregation Beth Israel-Judea in 2004 by the other two congregations. Traditional burial sections are designated for Congregations B'nai Emunah and Ner Tamid. A granite memorial honors Jewish war veterans from the time of the American Revolution through Desert Storm. (Courtesy author.)

An official stamp shows that the Chevrah Kadisha organization began on February 17, 1901. Records, however, indicate that the meetings were first held at 1641 Webster Street on October 17, 1915. When a building was constructed at Divisidero and Geary Streets in 1937, the name was changed to Sinai Memorial Chapel. Tradition holds that when the biblical Moses died in the Hebrew month of Adar, no one knew where he was buried and that the Chevrah Kadisha supposedly arranged for his burial. In 1965, with Stuart Greenberg as president, the Chevrah Kadisha group, which had taken the name Zion Adar, met with former prime minister David Ben Gurion of Israel. (Courtesy Sinai Memorial Chapel.)

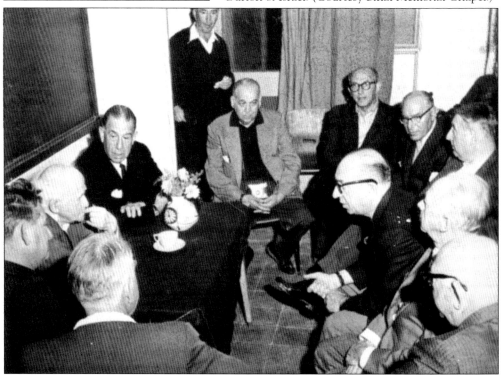

In 1897, nine people met in a small South of Market synagogue to help Jewish immigrants. Each agreed to put 25¢ a month into a special fund so that when $50 was accumulated, they could make the money available in interest-free loans. The first loan was for $10 to Jacob Goldberg, who repaid it in 10 months at $1 per month. The first eight loans totaled $37. Menachem Cohn, a kosher butcher, was the founding president (1897–1900). (Courtesy Hebrew Free Loan Association.)

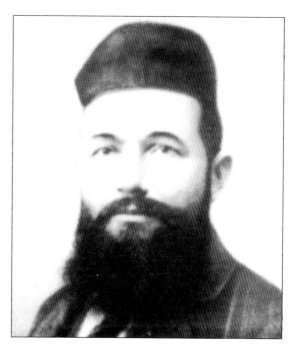

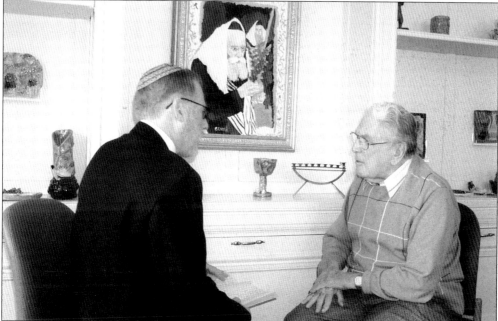

Julius Freedman arrived during gold rush days from czarist Russia and became a sea captain and trader. When he died in 1900, he willed his estate to the Hebrew Home of the Aged Disabled. Despite 18 years of litigation by apparent heirs, a modern edifice, now called the Jewish Home of San Francisco, was dedicated in 1923 at Mission and Silver Streets. Today the home is a licensed Medicare/Medi-Cal skilled nursing facility and residential community providing long-term and short-term care to the elderly in a traditional Jewish setting. Pictured are Rabbi Sheldon Marder, the chaplain for the Jewish Home of San Francisco, and Stephen Simon. (Courtesy Jewish Home of San Francisco.)

In 1997, the Greater San Francisco Unit 21 of B'nai Brith was created, combining the lodges in the Bay Area. The unit conducts a Passover seder in cooperation with the Jewish Family and Children's Services and the Jewish Women's International for the needy in the Tenderloin area. Members work Christmas at BART to allow employees to be with their families. Financial support is given to the Hillel Foundation and to the B'nai Brith Youth Organization. Russian-born Len Galant, who plays a major role in the unit's clothing drive, is pictured with Cantor Julius Blackman, former executive director of the Hebrew Free Loan Association. (Courtesy Julius Blackman.)

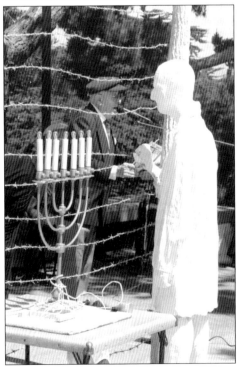

With the leadership of Cantor Julius Blackman and past president Emile Knopf, Unit 21 conducts a yearly Yom HaShoah observance at the Jewish Community Holocaust Memorial in Lincoln Park on Legion of Honor Drive. Created by George Segal, the memorial recalls the atrocities of World War II; six million Jews lost their lives. As a concentration camp victim looks on in front of the barbed wire, Henry Drejer, retired cantor of Congregation Beth Abraham and himself a survivor, chants the memorial prayer. (Courtesy author.)

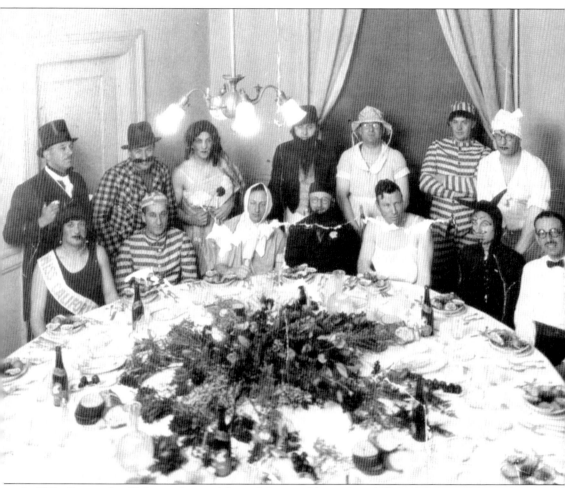

In 1921, Concordia Club members celebrated. Pictured here, from left to right, are (first row) Al Reyman, Jack Goldman, Marcel Hirsch, Leon Blum, Ed Gundelfinger, Al Lobree, and Jack Goldberg; (second row) Jack Lewin, Dick Stone, Charlie Weinshank Jr., Harold Silverman, Esmond Schapiro, Dan Stone Sr., and Sanford Stein. On December 1, 1939, two Jewish clubs were united to form the Concordia-Argonaut Club on Van Ness Street. (Courtesy Concordia Club.)

Three Jewish leaders in the 1950 business community were: Joseph Blumlein of S&W Fine Foods, Incorporated and future president of Mount Zion Hospital, Paul Bissinger of Bissinger and Company and future president of the chamber of commerce, and Daniel Koshland of Levi Strauss & Co. and future University of California Alumnus of the Year. (Courtesy Ann Blumlein Lazarus.)

From 1897 until 1948, the Jewish Educational Society functioned as a community Talmud Torah system. In 1949, under a changed name, the Bureau of Jewish Education established a system of affiliated congregational Hebrew schools. The attachment of a mezuzah marked the dedication of a library building for teacher training at 639 Fourteenth Avenue in 1976. Pictured here, from left to right, are Rabbi Morton Hoffman, associate director; Rabbi Bernard Ducoff, executive director; Max Pelzner, honorary life member; Sam Rosenberg, honorary life member; Phyllis Blackman, head librarian; and William Lowenberg, president of the bureau. (Courtesy Jewish Community Federation.)

With its move to the Jewish Community Federation building and the establishment by Dr. Ingrid Tauber of the Laszio N. Tauber Library and Reading Room in memory of her father, a Hungarian survivor, the Holocaust Center of Northern California annually reaches a multiethnic, multicultural audience of more than 30,000 Bay Area residents. Each year, more than 10,000 students meet survivors. The 15,000 volume library is open to the public and specializes in out-of-print Yizkor (Memorial) books, artifacts, documents, publications, and photographs. (Courtesy Holocaust Center of Northern California.)

In 1910, the Jewish Welfare Fund was established and later combined with the Eureka Society to form the Jewish Community Federation. By 1980, the Federation began to focus on Jewish education, culture, global Jewish needs, and other Jewish identity-building programs, as well as help for the needy. Each year, a Sunday telethon is held, and the Federation and its endowment fund give away 90¢ out of every dollar, making it one of the most efficient philanthropies in the United States. (Courtesy Jewish Community Federation.)

What once began as small celebrations in various locations around town has become one of the largest annual celebrations of Israel Independence Day in the country. Twelve thousand people from Northern California crowded Yerba Buena Gardens in 2005. With "Building Community" as its theme, Israel in the Gardens featured a mini Israeli Film Festival, an Israeli fashion show, a taste of Jewish Russia, an after party for young adults, interactive kids and family activities, and a Bay Area-wide children's choir. This photograph was taken at the celebration in 2006. (Courtesy author.)

The Bay Area Council for Soviet Jewry was initiated in mid-1967 by Harold Light, Sidney Klugar, Rabbi Morris Hershman, and Dr. Edward Tamler. Hal Light was the leader, selling his business and dedicating his life to the cause. In 1970, he helped form the Union of Council for Soviet Jews, where in 1974, at a meeting, he died of a heart attack. His wife, Selma, took over. In 1992, the Harold B. Light Emigration and Aliyah Information Center was opened in St. Petersburg. Pictured are Selma and Harold with Sen. Henry Jackson (D., Washington), coauthor of the Jackson-Vanik amendment linking the Soviet Union's "Most Favored Nation" status with the easing of emigration policy. (Courtesy University of Colorado Archives.)

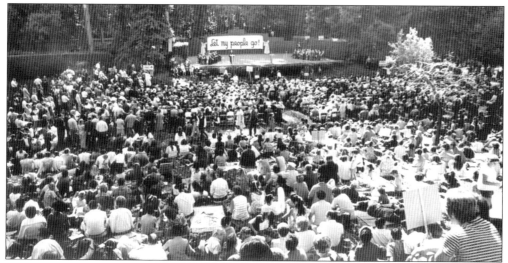

Ten thousand people participated at Stern Grove in the 1969 Soviet Jewry rally sponsored by the Bay Area Council. Rabbis from throughout the area participated in this event, which received national attention. (Courtesy University of Colorado Archives.)

The Chernyaks were "Refuseniks." First the father spent three years in a Soviet prison. Then when they applied for a visa to emigrate, the government refused to let the family leave the country, depriving them of their citizenship and their right to work. Eleven years later in 1988, under Gorbachev's Glasnost program, they were able leave Kiev and come to the United States. (Left to right) Helen today is a CPA and is married to Yanush Cherkis, and they have a one year old son Jaden. Edward (better known as Eddy) just graduated from UC Berkeley and is considering a law career. Alex for the last seven years has built his own electrical engineering company in which he bridges software with electronic design. Lina is a Licensed Clinical Social Worker (LCSW) at the Jewish Family and Children's Service and counsels Russian emigres in San Francisco and Palo Alto. (Courtesy Jewish Community Federation.)

Edith Green was one of the first persons to have an hour length, Monday through Friday, live cooking show on television, ruling the air waves in the Bay Area from 1949 to 1954, even beating out Arthur Godfrey in the review ratings. She demonstrated the family recipe of Marrow Balls, a tiny matzah dumpling made with beef marrow instead of chicken fat, which was considered the Jewish dish given to the world. Edith's family goes back to Rabbi Gershom Mendes Seixas, one of 14 clergy assisting in the inauguration of George Washington. (Courtesy Donald Green.)

Seven

TODAY'S JEWS

The seven regions of the "Bay Area," contain the third largest metropolitan Jewish population in the United States—350,000 and growing. In the center stands San Francisco, 70,000 strong.

- Former Soviet Union emigres account for 8 percent of all Jewish households and live mainly in San Francisco County and the peninsula.
- Israeli identified households constitute 4 percent of all Jewish households and comprise 13 percent of all Jewish households in the South Peninsula.
- Half of all married couples include a non-Jewish partner, but they are more connected to the Jewish community than interfaith couples nationally. As many children are being raised by one Jewish parent as by two.
- Concern about anti-Semitism cuts across all sectors of the community.

—The 2004 study by the Jewish Community Federation of San Francisco, The Peninsula, Marin and Sonoma Counties.

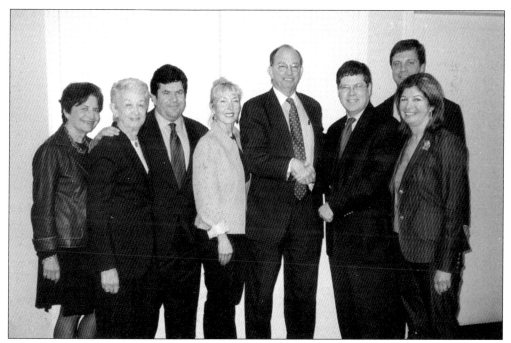

The 2006 professional and volunteer leaders of the Jewish Community Federation, from left to right, are endowment fund executive director Phyllis Cook, past president Adele Corvin, incoming president John Pritzker, board member Liki Abrams, Federation CEO Tom Dine, president David Steirman, treasurer Michael Jacobs, and secretary Barbara Farber. (Courtesy author.)

Israeli Consul General David Akov and Cultural Attaché Tamar Akov welcomed the entire Jewish community to Israel's 58th Independence Day celebration in 2006 at the Legion of Honor. (Courtesy author.)

Rabbi Brian Lurie, CEO of the Jewish Community Federation (1974–1991), oversaw the expansion of the local organization to Sonoma, Marin, and the North and South Peninsulas. The Osher and Schultz Centers, the Jewish Museum, and the Steuart Street Federation buildings were established, and an office and sister-city program opened in Israel. Now devoting himself to projects in Israel, Rabbi Lurie meets with Avram Burg, head of the Jewish Agency, and Shimon Perez, former prime minister of Israel. (Courtesy Rabbi Brian Lurie.)

Krakow-born Tad Taube, founder of the Jewish Polish Heritage Program, welcomes to San Francisco Aleksander Kwasniewski, the former president of Poland who five years ago offered to the Polish Jewish community the first formal apology for the atrocities of the Holocaust. The major goals of the Jewish Polish Heritage Program are to recover Poland's pre–World War II Jewish culture; to preserve, sustain, and restore Jewish facilities; to acquire Jewish artifacts; and to improve the lives of contemporary Jews. (Courtesy Lionel ad Silva.)

Roselyn "Cissie" Swig (right), chair of the board of trustees at the Contemporary Jewish Museum, celebrates the museum's opening exhibition, *Art of Living: Contemporary Photography and Video from the Israel Museum* with Nina and Daniel Lambskin, architect of the Berlin Holocaust Museum and the new Contemporary Jewish Museum facility. To be completed in 2008, the new museum will be located near the Yerba Buena Gardens. (Courtesy Contemporary Jewish Museum.)

Earl Raab, who influenced the direction of Jewish community relations nationwide, served as the first executive director of the San Francisco Council (1951–1987). He writes extensively on blacks and Jews, Israel and American Jews, anti-Semitism, and anti-Zionism. He is pictured at work in this 1955 photograph. (Courtesy Jewish Community Federation.)

Though retired as the second executive director of the JCRC, Rita Semel does not stop. Today she is the executive vice chair of the Interfaith Council and Co-Convener of the Council on Homelessness. A recipient of numerous awards, she continues on as a member of many Jewish and community boards. Rita is pictured toward the end of the 1980s with her late husband, Max. (Courtesy Jewish Community Federation.)

Rabbi Douglas Kahn, a fourth-generation San Franciscan, was ordained at the Hebrew Union College-Jewish Institute of Religion and serves as the third executive director of the Jewish Community Relations Council. The JCRC represents some 80 synagogues and organizations on issues of vital concern to the Jewish community. Rabbi Kahn participated in the interfaith demonstration on behalf of Darfur relief at city hall. (Courtesty author.)

George Krevsky was the 2006 recipient of the Guardian of Democracy Award for his many years of commitment to the New Israel Fund. In the photograph, George welcomes Israeli artist Michael Kovner, the son of Abba Kovner, Israeli poet and resistance fighter, whose landscapes of the sea and mountains depart from his father's war-torn legacy to create more timeless terrains. (Courtesy author.)

Hadassah members Martina Knee, Sandra Lipoids, Terry Rosen Stock, president Deborah Lopez, chapter director Lepta Hillman, Ruth Levy, and Gil Hoffman, political correspondent for the *Jerusalem Post*, attend an explanation of Blueprint Negev, the Jewish National Fund's project to move 250,000 new residents into 100,000 new houses in the Negev within the next five years. In 2005, the Hadassah Medical Organization was nominated for the 2005 Nobel Peace Prize. Hadassah is a major backer of JNF's Blueprint Negev program. (Courtesy author.)

Founded in 1927 to assist European Jews in the aftermath of World War I, ORT has grown into a global network of schools to educate nearly 300,000 students a year to achieve economic self-sufficiency through scientific, technological, and vocational training. Pictured, from left to right, are Hope Kessler, international executive director, Dorothy Spiegelman, founding president of the San Francisco chapter, and Francoise Rothstein. (Courtesy author.)

In 2005, Lee Levin, working in the biotech industry, joined 11 others on a mission to Uganda, sponsored by the American Jewish World Service, to see at first hand the devastation of AIDS and to work with needy communities in order to promote productivity, innovation, and self-reliance on the part of women, children, youth, and persons with disabilities. He also met the Abayudaya, the native Jews of Uganda. (Courtesy American Jewish World Service.)

Bert Steinberg (right), recipient of a lifetime achievement award from the International Federation of Secular Humanistic Jews, is congratulated by Rabbi Jay Heyman (left) of Congregation Kol Hadash and Rabbi Sherwin Wine, the international president. (Courtesy author.)

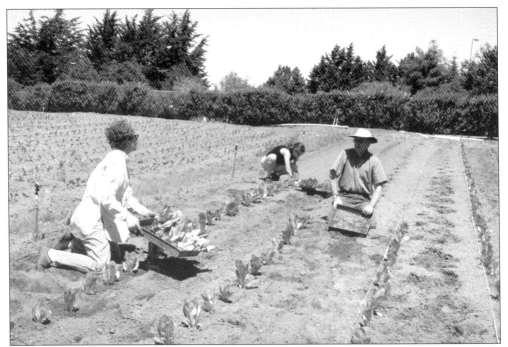

The Peah Garden section of Temple Emanu-El's Home of Peace Cemetery in Colma is being used as an organic produce garden tended by volunteers. In 2005, the garden's 30,000 pounds of vegetables was the largest contribution of fresh produce to the San Francisco Food Bank. (Courtesy author.)

Associate Supreme Court Justice Stephen Breyer, Lowell High School class of 1955, visits his alma mater while on a tour for his new book *Active Liberty: Interpreting our Democratic Constitution*. (Courtesy Sam Bowman, student at Lowell High School.)

The slogan of the 1992 campaign button was fulfilled with the election of Barbara Boxer and Diane Feinstein, two Northern California Jewish women, to the United States Senate. (Courtesy HUC Skirball Cultural Center, Museum Collection; photograph by Lelo Carter.)

Michael Tilson Thomas, music director of the San Francisco Symphony, is the grandson of pioneer actors, producers, and theater owners Boris and Bessie Thomashefsky, who used the Yiddish theater in America as a "force for cultural transformation." His *The Thomashefskys: Music and Memories of Life in the Yiddish Theater* brought to the forefront their lost historical work, which provided the underpinning for Broadway and for the golden age of American songwriting on Tin Pan Alley. (Courtesy Jewish Community Federation.)

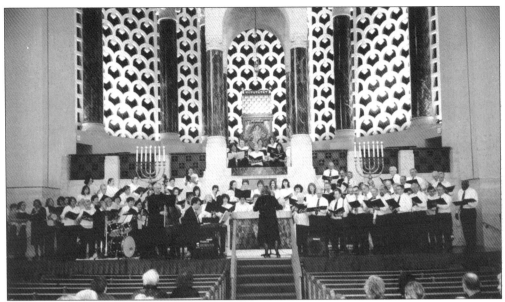

The Northern California Board of Cantors presented the 2006 Zimriyah to raise money to help stop the genocide in Darfur, Sudan. The combined choirs of Temples Emanu-El and Sherith Israel of San Francisco, B'nai Sholom and B'nai Tikvah of Walnut Creek, Rodef Sholom of San Rafael, the Shirim Choral Society of the Peninsula, and the East Bay Jewish Folk Chorus were under the direction of Cantor Roslyn Barak of Temple Emanu-El, with accompanist Barry Koron. (Courtesy author.)

Marilyn Sachs holds her recent book, *Lost in America*, the story of a Jewish survivor whose family perished in Auschwitz. The author of over 40 books for children between the ages of eight and 12, she has been a finalist for the National Book Award and the winner of the American Jewish Library Award. Morris Sachs, born into a Workmen's Circle family, studied with Chaim Gross and has had a lifelong love affair with carving in wood. In the picture are his works *The Leap* (left) and *Wild Hair* (right). His biblical sculptures now reside in the homes of art collectors. Marilyn and Morris have been married for 59 years. (Courtesy author.)

The Anna Davidson Rosenberg Awards for Poems on the Jewish Experience were established in 1987 at the San Francisco Jewish Community Center. Paula Friedman first developed the program, and local poet Dan Bellm, a previous award winner and judge, chaired the 2006 presentation. Pictured are Ilya Kaminsky (judge), Judith Goldhaber (Berkeley, tied for first prize), Sandra Tarlin (New York, second prize), Jehanne Dubrow (Nebraska, honorable mention), Bellm, and Marcia Lee Falk (Berkeley, tied for first prize). (Courtesy author.)

Many diverse art forms created by Bay Area artists were displayed at the Bureau of Jewish Education Community Library exhibition *Freud, Moses and Monotheism: Community Artists See the Psyche*. Participating artists, from left to right, are (first row) D. Jeanette Nichols, Allen Shaun, Max Shaun, Amy Assoil, Beth Grossman, and Judith Cerebrum; (second row) Jennifer Kaufman, Barbara Winer, Lisa Berkelhammer, Barbara de Groot, Trudi Chamoff Hauptman, Barbara Mortkowitz, Ruth Jaskiewicz Caprow, Helene Fischman, Richard Adler, Susan Duhan Felix, and Freida Reider. Lawrence Felinghetti's lithograph *Freud–Life is a Real Dream* is visible in the upper right. (Courtesy Ruth Caprow.)

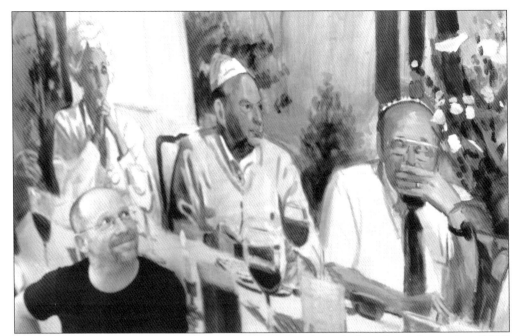

Stanley Goldstein's robust and affectionate paintings of people have been featured in *7 X 7*, *American Art Collector*, and the front cover of *Art & Antiques*. His rediscovery of family connections percolated in him until he brought to life the *Family Seder* in a monumental 10-foot painting. (Courtesy author.)

As early as 1855, the Jewish settlers published *The Gleaner*. Eight years later *The Hebrew* appeared but died shortly after. In 1895, *The Emanu-el* came into existence, and in the late 1920s, it was joined with *The Jewish Journal*. In 1945, the combined paper became *The Jewish Community Bulletin*. The present-day *J.*, the Jewish news weekly of Northern California, is its successor. Editor and publisher Marc S. Klein and associate publisher Nora Contini have been running the newspaper for more than 21 years. (Courtesy *Jewish News Weekly*.)

The Alfred and Hannah Fromm Lifelong Learning Center, widely acknowledged as the first of its kind in the United States, started as a pilot project in 1976. Today it has its own home on the University of San Francisco campus, where each year, its 1,100 students, ages 50 and above, have choices from among 60 courses. Caroline Fromm Lurie is the president of the Friends of the Fromm Institute. (Courtesy Fromm Institute.)

Ze'ev Brinner, who lived "South of the Slot" on Moss Street, and Lisa Kraus Brinner, a Holocaust survivor of an unaccompanied children's train from Vienna to London, are known for their lifetime commitments to Israel and community service. Lisa is a retired dietician in the health sciences, and Dr. Brinner is the professor emeritus of Near Eastern Studies at the University of California, Berkeley. (Courtesy author.)

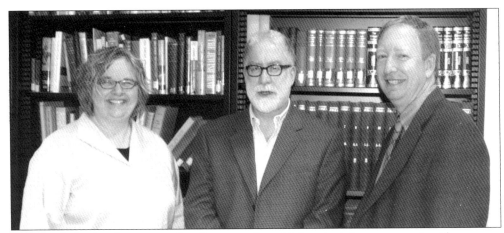

The Jewish Studies Program at San Francisco State University brings a strong Jewish presence to the diverse campus life and reaches out to the larger Bay Area through its public events. The faculty consists of assistant professor Kitty Millet, Ph.D. (left), professor and director Fred Astren, Ph.D., and the Richard and Rhoda Goldman Professor in Jewish Studies and Social Responsibility Prof. Marc Dollinger, Ph.D. (Courtesy author.)

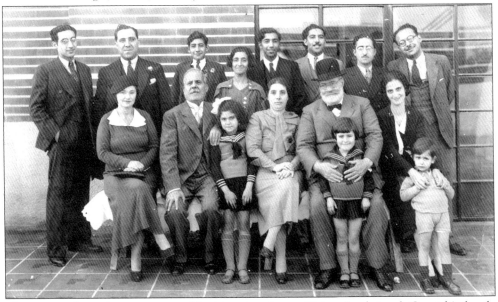

There were three distinct waves of Jewish migration to China. Leah Jacob Garrick's family history goes back to the first group of 500 to 700 Sephardic immigrants. In the 1850s, following Arab pogroms in Baghdad, her grandfather and great-grandfather came to Shanghai via Bombay with the Sassoon family. Leah and her father both were born in Shanghai. The second wave of Jews that fled the Czarist pograms at the end of the 20th century, and the third group of 20,000 that escaped from Nazi Germany, were welcomed by the Sephardim. This 1935 Shanghai image shows, from elft ot right, (first row) Rebecca or Becky (Leah's mother), J. I. Jacob (grandfather), Leah (eldest daughter), Aziza (grandmother), and Sasson Abraham (Aziza's father and Leah's great-grandfather), Rachel or Ritchie (second daughter), Rosie (Joe's wife), and Sonny (their son); and (second row) Aaron, Isaiah (Leah's father), Solly, Hilda, Ellis, Moses, David, and Joe. Not in photograph: Isaac Hai who was in London. Leah and her family arrived in San Francisco in 1947. (Courtesy Leah Jacob Garrick.)

A fourth-generation San Franciscan, John Rothmann's love is his 15,000-volume library specializing in American political history and Judaica. One of the Bay Area's strongest pro-Israel advocates and a fervent advocate of positive Jewish identity, he is being honored for extraordinary efforts at the 2006 Israel in the Gardens event. An author, archivist, political consultant, lecturer for Elderhostel, and faculty member of the Fromm Institute University of San Francisco, his ability to make radio come alive can be heard on KGO Newstalk 810 AM. (Courtesy Roger Dorfman.)

Michael Krasny, professor of English at San Francisco State University and host and senior producer of Forum on KQED-FM, the National Public Radio affiliate, is pictured celebrating his 10 years in public radio. Though the mustache has since disappeared, his voice continues to be heard on the air every Monday through Thursday morning. (Courtesy Michael Krasny.)

A Torah study group started more than 20 years ago continues to meet each Friday morning at 8:00 a.m. in a downtown business office. Present at picture taking, from left to right, are (first row) Ernest Newbrun, Daniel Goldberg, Maurice Edelstein, Michael Franzblau, and Albert Hassid; (second row) Norman Zilber, Michael Thaler, Ed Tamler, Reuven Jaffee, Jonathan Chait, Seth Kaufman, Nat Schmelzer, Rabbi Jacob Frankel, Henry Krivetsky, and George Krevsky. (Courtesy author.)

Family historians come to the Jewish Community Library on the first Sunday of each month for the "one-on-one help with your family tree" program with longtime library volunteer staffer Judy Baston of the San Francisco Bay Area Jewish Genealogy Society. Pictured, from left to right, with some of the many reference books the group investigates are (first row) Talia Shaham, Judy Baston, Phyllis Boronson, and Marian Rubin; (second row) Dana Miller, Allen Klein, Bill Schweitzer, Steve Harris, Joel Bauman, Jeff Lewy, and Ron Arons. (Courtesy author.)

Jewish Coalition for Literacy (JCL) reading specialist Joan Green (right) trains student Danielle Winocur and parent Karen Thurm Safran at the Gideon Hauser Jewish Day School to become tutors. High-risk children from underserved public elementary schools are helped by volunteer Bay Area tutors in after-school programs. (Courtesy Jewish Coalition for Literacy.)

Temple Emanu-El members prepare to lead Torah study sessions during the 49 days between Passover and Shavuot by examining the Torah accounts of the events at Sinai. Pictured, from left to right, are Deborah Bloch, Jill Kneeter-Zerin, Donna Craft, and Susan Shargel; (second row) program coordinator Adam Eisendrath, director of youth education Abra Greenspan, Jill Jacobs, Linda Kalinowski, David Goldman, and Harris Weinberg. (Courtesy author.)

After completing a comprehensive four-year general and Judaic college preparatory program, the 2005 graduates became the Jewish Community High School of the Bay's first, or pioneer, graduating class. (Courtesy Jonathan Carey/ Blue Star PR.)

116

At the 2006 Day of Learning of the Northern California Holocaust Center, Bay Area Jewish high-school students, who had spent two weeks in Poland and Israel under the Shalhevet program, talk with Mira Shelub, a survivor and today an outreach worker for the L'Chaim Adult Day Health Center. Pictured, from left to right, are Naomi Shiffman, Len Gadye, Morgan Blum (head educator for the Holocaust Center), Mira Shelub, Kate Harrison, Dophia Alyssa Simpson, Shelley Minnert, and Ariana Estoque and Jaire Mikowski (Shalhevet leaders). (Courtesy author.)

A tradition started in 1840, and for the next 43 years, Selina Seixes Solomons recorded the births, marriages, and deaths in her family bible. Her only married granddaughter, Adele Solomons Jaffa, continued the practice for 64 more years. Edith Solomons Green, Adele's closest niece, kept the tradition for 43 additional years, and Edith's son Donald, with his son Aryeh looking on, records in the same bible the birth of his grandson Yonatan Green. (Courtesy Donald Green.)

The tefillin consist of two dyed black leather boxes made of the skins of kosher animals and of dyed black leather straps made of the veins of kosher animals that, each morning with the exception of the Shabbat and the Holy Days, are placed on the arm and the forehead by men who have been Bar Mitzvah (i.e., age 13). They are boxes containing scriptural passages to serve as symbolic reminders that God took the Israelites out of Egypt with a mighty hand (Exodus 13:16) While women are exempt, some Modern Orthodox hold that it is permissible but discouraged. Many Conservative and Reconstructionist congregations do encourage women to lay tefillin. In Reform Judaism today, it is permitted, though practiced by relatively few men or women. Dr. Sheppard M. Levine of Orthodox Congregation Adath Israel is pictured laying the tefillin. David Libricki is in the background. (Courtesy Jonathan Keyak.)

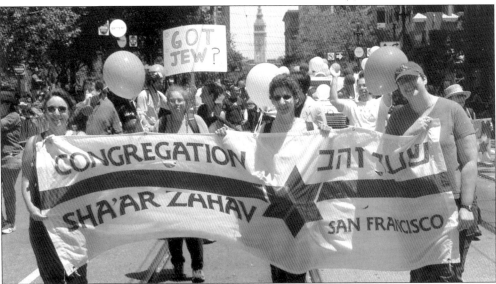

Shaar Zahav, established in 1977, is a progressive Reform synagogue composed of lesbian, gay, bisexual, transgender, and heterosexual Jews together with lovers, families, and friends, both Jewish and non-Jewish. The rabbis, lay leaders, and members join together to bring meaning to the Torah and Jewish observance, and they are committed to prayer, study, mitzvot, and tikkun olam (repairing the world). Pictured in the Pride 2005 Parade, from left to right, are Gina Centanni, Lydia Radovich, Randy Blaustein, and Abi Weissman. (Courtesy Congregation Shaar Zahav.)

It began with a group of former Russian "graduates" of San Francisco Hillel. Today Club Ring is a Russian-interest network group for Russian-speaking people, ages 25 to 40-plus, to meet and communicate. Pictured here, from left to right, are (first row) Alexey, Taya Gavrilova, Lubomir Goldshteyn, Joshua Kerzhner, Anton Tsatskin, and Alex Teplitsky; (second row) Irina Birman, Stanislav Tsatskin, Mila Tsatskin, Tatiana Kershner, and Alex Teplitsky. (Courtesy author.)

Jews in the Near East and North Africa (JIMENA), organized in 2003 with the aid of the Jewish Community Relations Council, lobbies Congress asking that whenever the rights and concerns of the Palestinians are addressed the nearly 900,000 Jews, who were expelled or forced to flee from Arab countries, also be mentioned. Jimena members Rachel Bernstein from the United States and Shai Shaul from Yemen met in Israel and were married in a Yemenite ceremony with grandma Naomi Shaul looking on. Today Shai is a mechanical engineer who graduated from San Francisco State University. (Courtesy Rachel and Shai Shaul.)

119

Two Art Institute students, two Contemporary Jewish Museum fellows, a cantor, a jazz singer, an architect, musicians, and artists gather in a North Beach flat for a Passover seder across the street from where Allen Ginsberg wrote his poem *Howl*. All are San Francisco residents who come from four different countries: United States, former Soviet Union, Mexico, and Israel. Pictured, from left to right, are (first row) Ruth Jaskiewicz Caprow, Michelle Arrieta, Barbara Linn Powell, and Ari Caprow; (second row) Rob Powell, Vladimir Rabichev, Natali Rabichev, Ann Phelan, Nili Yosha, and Jonathan Silvio. (Courtesy Ruth Caprow.)

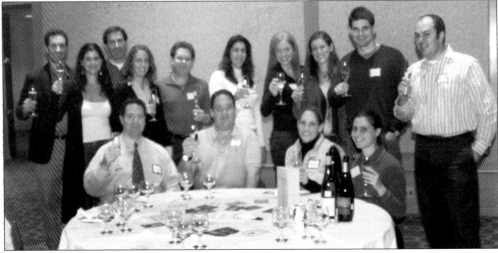

The 2006 Young Adult Wine and Food Pairing Class of Temple Emanu-El convenes for a three-part evening, consisting of four different kinds of wine, varieties of take-out cuisine, and a teacher who knows what he is talking about. These small groups form a good way for young adults to know each other. Mollie Schneider (first row, right) is the group coordinator. (Courtesy author.)

Brandeis Hillel Day School is a CAIS- and WASC-accredited coeducation independent K–8 Jewish day school, where parents, faculty, staff, and students partner in building strong academic foundations in Hebrew, Judaic studies, the language arts, the sciences, the social studies, and mathematics. Housed in a state-of-the-art building, the program simultaneously explores the spectrum of Jewish life and reaches out to the world at large. (Courtesy Brandeis Hillel Day School.)

At first, there are three to set up the chairs for the Shabbat service: David Henkin, professor of history at UC Berkeley; Gussie Falleder; and Eva Jo Meyers, and then there are 60 people chanting together. Members take turns leading the Shabbat service. No rabbi. No announcing of pages. Everyone just starts. The Mission Minyan Prayerbook is their own, based on that of the Boston Chavurah. This is the small service. On the first Shabbat of the month, more than 100 celebrate with song, prayer, and dinner. During the week, they study Mishnah and observe Tikkun Layl Shavuot for the Feast of Weeks. (Courtesy author.)

This book started with the story of Louis Sloss. Today fourth-generation descendant Peter Sloss, a board member of the Jewish Coalition for Literacy, and his wife, Rebecca Martinez, view her photography at the Krevsky Gallery Baseball Exhibit. (Courtesy author.)

The Bureau of Jewish Education Jewish Community Library at the Jewish Community Center is a place to catch up on most popular Jewish volumes. Volunteers assist those who wish to borrow books. Felix Warburg examines one of the new publications. (Courtesy author.)

What do three creative people talk about when they are in conversation in the Pottruck Family Atrium of the Jewish Community Center? As a starter they might talk about the community center, the congregation, or what it is like to be an Orthodox woman teacher; however, before long they probably will talk about the modern equivalence of three famous Jewish questions: "What's going on in my life?," "What's next?," and "How do I get there?" Pictured here, from left to right, are Rabbi Yoel Kahn, Rabbi Peretz Wolf-Prusan, and Emily Shapiro-Katz. (Courtesy author.)

It is always lively when Rabbi Jacob Frankel (right) and Dr. Reuven Jaffe get together (Courtesy author.)

Chabad rabbi Raleigh Resnick welcomes everyone at the Israel in the Gardens celebration and invites the men to put on tefillin (phylacteries). (Courtesy author.)

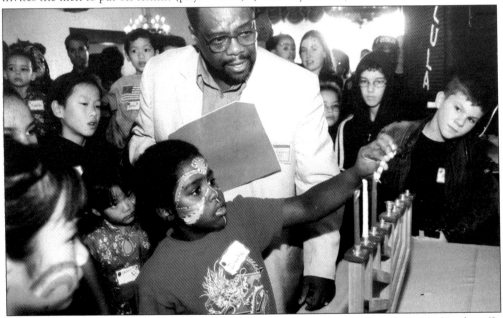

The Institute for Jewish and Community Research is a public policy think tank. Be'chol Lashon (*In Every Tongue*), a program of the institute, seeks to grow and strengthen the Jewish people through ethnic, cultural, and racial inclusiveness. Of the roughly 6 million Jews in the United States, 1.2 million, or 20 percent, are of African American, Asian American, Latino, Middle Eastern, Spanish, Portuguese, or mixed-race descent. In addition to being born of a Jewish parent, other paths to Judaism are conversion, adoption, and intermarriage. One does not have to choose between racial, ethnic, and religious identities. Rabbi Capers Funnye, a spiritual leader of the Be'chol Lashon community, is pictured leading San Francisco children in lighting the Chanukah candles. (Photograph from *In Every Tongue*, Institute for Jewish and Community Research, 2005.)

It began in a grocery at the corner of Henry and Noe Streets, where Rosemary and Irving Rothstein met in 1991. Their romance grew when they visited his mother, who said, "You ought to teach her Yiddish. Zie iz a zisse freu, a shayneh lady (She is a sweet woman, a lovely lady.)" They were married by Rosemary's father, a deacon in the Episcopal Church. In 2005, Rosemary converted to Judaism, and she and Irving were married by Rabbi Tracy Nathan. Rosemary, active in the design industry with a beautiful sense of color in clothes and gardening, now is studying Hebrew. Irving, a retired teacher, is a published author of stories about the teaching profession. (Courtesy Brian E. Geller.)

Rabbi Edward Zerin, author of *Jewish San Francisco*, uses a feather pen to write his letter in the Fredrica Levin Lewis Torah, as scribe Neil Yerman guides his hand. (Courtesy Susan Adler Photography.)

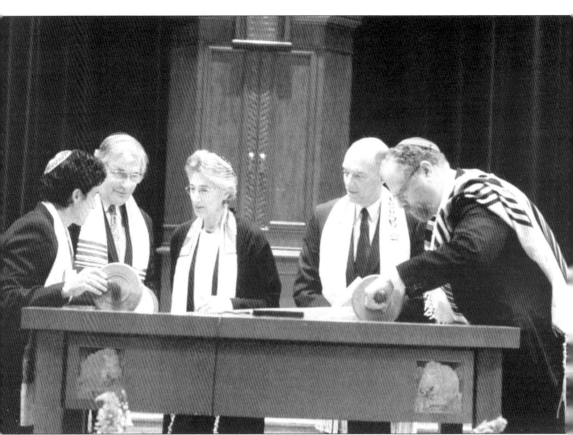

As part of its "Year of Torah" in 5766, corresponding to 2005–2006, Temple Emanu-El wrote a new Torah in fulfillment of the 613th mitzvah. Upon completion, the Fredrica Levin Lewis Torah was welcomed into its new home at Shavuot (the Festival of Weeks) in a ceremony known in Hebrew as Hach'nasat Sefer Torah. After the last letter in the Book of Deuteronomy was inscribed, the Torah was rerolled to the beginning so that the first word could be inscribed in the Book of Genesis. Pictured here, from left to right, are Rabbi Sydney B. Mintz, Scribe Neil Yerman, Rabbi Helen T. Cohn, Rabbi Stephen S. Pearce, and Rabbi Peretz Wolf-Prusan. (Courtesy Susan Adler Photography.)

EPILOGUE

Today's Jews are significantly involved in philanthropy. In the Jewish community, their beneficence is omnipresent. In the general community, their generosity and leadership are to be found at the San Francisco Symphony, Ballet, and Opera; at the Museum of Modern Art; at the Public Library; at hospitals and welfare centers; and at hosts of other organizations and institutions. The following, courtesy of the Jewish Community Foundation, is a 2006 partial list of major San Francisco Bay Area Jewish Foundations:

Gerson and Barbara Bakar Foundation
Columbia Foundation
Helen Diller Family Foundation
David B. Gold Foundation
Richard and Rhoda Goldman Foundation
Eucalyptus Foundation
Friend Family Foundation
Friedman Family Foundation
Miriam and Peter Haas Foundation
Walter and Elise Haas Foundation
Hellman Family FoundationKoret Foundation
Laura and Gary Lauder Philanthropic Fund
Levine-Lent Fund
Alexander M. and June L. Maisin Foundation
Bernard Osher Jewish Philanthropic Foundation
Claude and Louise Rosenberg Foundation
Richard and Barbara Rosenberg Philanthropic Fund
Albert and Janet Schultz Supporting Foundation
Saal Family Foundation
Mae and Benjamin Swig Supporting Foundation
Taube Foundation for Jewish Life and Culture

INHERITING THE PAST

PARTICIPATING IN THE PRESENT

BUILDING THE FUTURE

ACROSS AMERICA, PEOPLE ARE DISCOVERING SOMETHING WONDERFUL. THEIR HERITAGE.

Arcadia Publishing is the leading local history publisher in the United States. With more than 3,000 titles in print and hundreds of new titles released every year, Arcadia has extensive specialized experience chronicling the history of communities and celebrating America's hidden stories, bringing to life the people, places, and events from the past. To discover the history of other communities across the nation, please visit:

www.arcadiapublishing.com

Customized search tools allow you to find regional history books about the town where you grew up, the cities where your friends and family live, the town where your parents met, or even that retirement spot you've been dreaming about.